Historic England

G000048945

London's
East End

Michael Foley

AMBERLEY

Sue and Barry Felstead, very special friends

First published 2017

Amberley Publishing
The Hill, Stroud, Gloucestershire, GL5 4EP
www.amberley-books.com

The images on the following pages are reproduced by permission of Historic England: 6, 7, 8, 9, 10, 11, 12, 13, 14, 15, 16, 17, 18 (upper), 20, 21, 22, 23 (upper), 26 (lower), 27 (lower), 29, 30, 31 (upper), 32, 33, 34, 35, 40, 41, 42, 45, 46, 47, 48, 49, 50 (upper), 51, 52, 53, 54, 55, 56, 57 (lower), 58 (lower), 59, 61, 62, 63, 64 (upper), 65, 67, 68 (upper), 69, 70 (upper), 71, 73, 74, 75, 76, 77, 78 (lower), 79 (upper), 80, 81, 82, 83, 84, 85, 86 (upper), 87, 88 (lower), 89 (upper), 90, 91, 92, 93 (upper), 94, 95.

The images on the following pages are © Historic England (Aerofilms Collection): 19, 27 (upper), 58 (lower), 72 (lower), 79 (lower), 86 (lower) 89 (lower), 93 (lower).

The following images are © Historic England: 23 (lower), 24, 25 (upper), 26 (upper), 28, 36, 37, 38, 39, 50 (lower), 57 (upper), 64 (lower), 68 (lower).

The following images are © Crown copyright Historic England Archive: 25 (lower), 43, 44, 60 (lower), 66 (lower) 70 (lower.

The following images are from the author's own collection: 18 (lower), 31 (lower), 60 (upper), 66 (upper), 72 (upper), 78 (upper), 88 (upper).

ISBN 978 1 4456 7664 7 (print)
ISBN 978 1 4456 7665 4 (ebook)

British Library Cataloguing in Publication Data.
A catalogue record for this book is available from the British Library.

Origination by Amberley Publishing.
Printed in Great Britain.

Contents

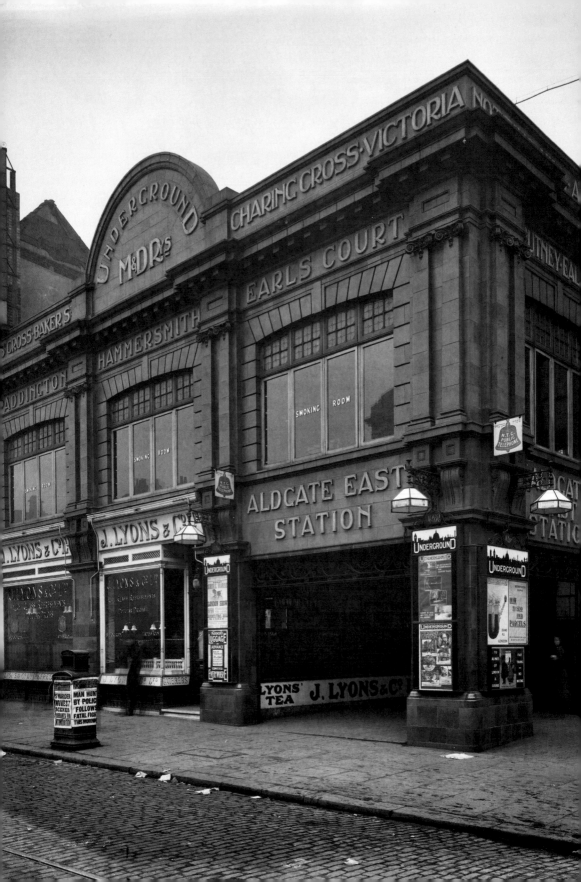

Introduction

When writing about the East End of London it is always difficult to confirm where it begins and ends. I have always thought that it began east of Tower Bridge and was only on the north bank of the Thames. However, as the docks and the East End go hand in hand, I have included part of the Pool of London up to London Bridge in these images. Then, due to there being less development south of the river, I have also included Southwark and Bermondsey as it is there that, in my opinion, the most distinctive historic docklands character can be found.

Whatever the limits of the East End, it has always been seen as the poor relation of the City of London. From medieval times the area east of the city walls was the home of the less desirable elements of the capital's population. During the Napoleonic Wars it was even said that the population of the East End were to be more feared than Napoleon's army.

There have, though, always been more affluent pockets in the east. Once away from 'Central London' the area that was once Essex became one of small villages with a number of large houses for the better-off. It was improved transport links such as the coming of the railway that led to the expansion of London, swallowing up the small villages such as West Ham and Stratford that had once stood in Essex. The expansion continued into the twentieth century, into the now London boroughs of Barking and Havering and the wooded areas of Waltham Forest.

It was also during the nineteenth century that the East End established its long-lasting reputation of being an area dominated by industry and the docks. Many of these industries were dangerous for the workers and there is a history of industrial disease and disasters that caused hundreds of deaths among the poor employees. During both world wars – but especially during the second – it was the East End that suffered the brunt of enemy bombing.

As will be seen from this series of old images, much has changed. Some of the old buildings may look remarkably similar, but often the usage of them has altered. The population of the area has also changed and now those who live in the East End are more likely to have their roots in other parts of the world rather than in other parts of London. The docks are gone, replaced in many cases with much grander buildings, and the river is now full of pleasure rather than working craft.

The East End is a fascinating area with numerous cultures and races living side by side. The shops and markets sell goods unimaginable even in the recent past. Along with areas that are still poor in relation to the City, there are more affluent parts that often border some of the largest open spaces in London. Whatever your interest, hopefully you will find something to satisfy in the varied images of what is now East London.

Tower Hamlets

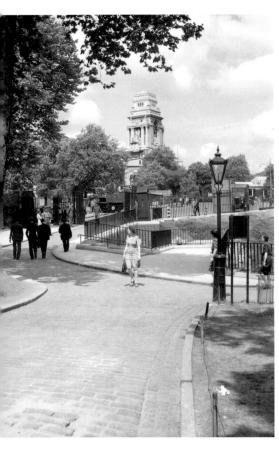

Left: Port of London Authority
The Port of London Authority Building in Trinity Square is shown in this image as seen from Tower Gardens after the Second World War. The building was built between 1912 and 1922 – interrupted by the war – by Edwin Cooper and housed those responsible for the docks in London. The building was closed in 1971 along with many of the docks.

Below: Pool of London
The Pool of London looking towards Tower Bridge from the west. The docks are always associated with East London but in the past large ships could reach as far as London Bridge because Tower Bridge could be raised. Goods from the ships were then often carried further along the river in strings of barges pulled by tugs.

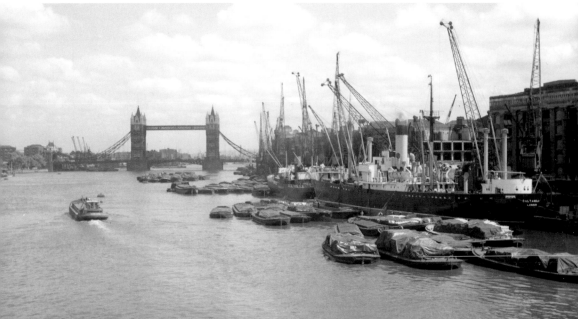

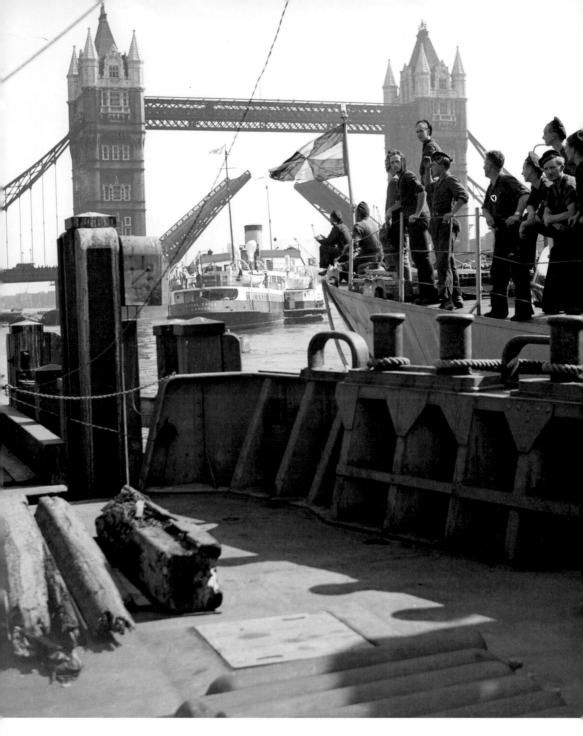

Tower Bridge

Tower Bridge is shown raised to allow a ship to pass under it. The site of Tower Bridge was chosen due to the rapid development of the East End in the late nineteenth century. A fixed bridge would have denied entry to the Pool of London, so the design was chosen from entries in a competition. The competition had one stipulation: that the bridge could be raised.

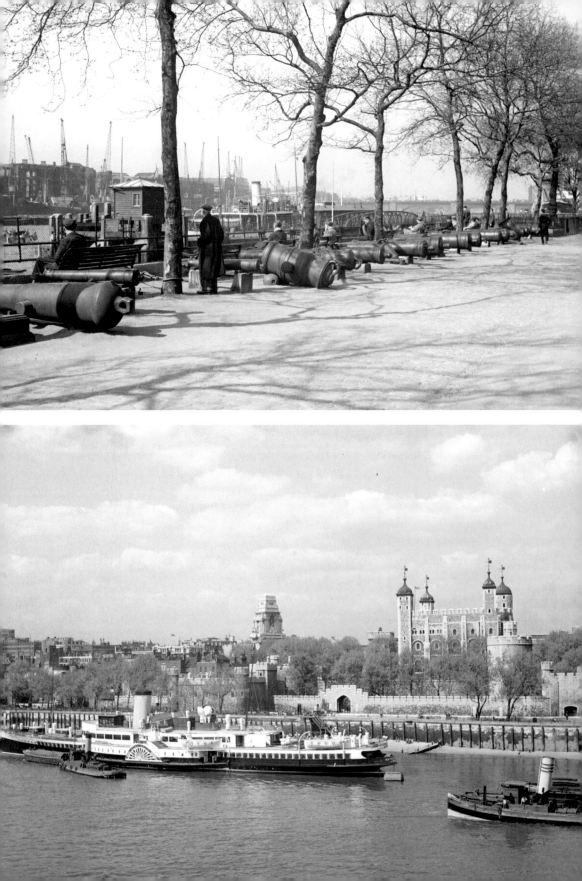

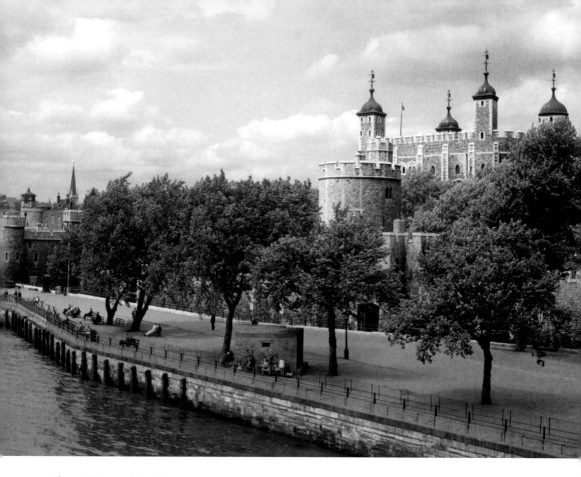

Above: Tower of London

The Tower of London has looked out over the River Thames since it was built by William the Conqueror after his victory at the Battle of Hastings. It is now one of London's busiest tourist attractions as well as the housing the Crown Jewels. It is also the home of some of London's best-known characters, the Yeoman Warders or Beefeaters.

Opposite above: Tower Gardens

Tower Gardens with cannons looking across the river towards Wilson's and Hay's wharves. Hay's Wharf once extended from Tower Bridge to London Bridge along the south bank of the river and was known as part of London's larder due to the amount of foodstuffs that arrived there by ship.

Opposite below: Royal Eagle

It was not only ships carrying goods that arrived in the Pool of London. The image shows the *Royal Eagle*, which was one of a number of steamships that carried passengers up and down the Thames and around to coastal towns in the nineteenth and early twentieth century. It was one of these ships, the *Princess Alice*, that led to the worst disaster ever on the Thames in the late nineteenth century when it was struck by another ship while full of day-trippers. The image shows the *Royal Eagle* at her mooring.

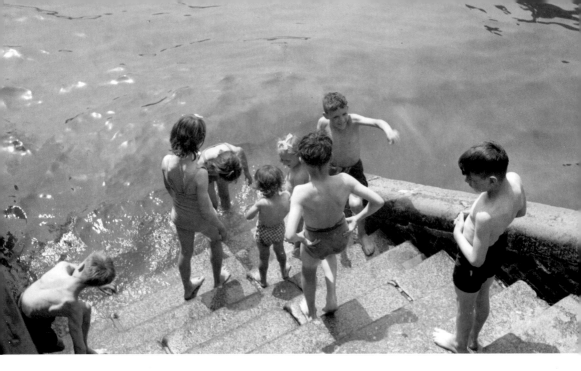

Above: Paddling in the Thames
An image from just after the Second World War showing children paddling in the River Thames on the steps alongside Tower Pier. It is hard to imagine this being possible with the number of ships and the busy docks along the river at this time or by today's health and safety standards.

Below: London's Seaside
Another post-war image showing that not only children found a recreational use for the Thames in the Pool of London. Trips to the seaside were rare in post-war Britain for poorer families. The Thames was an easily reachable alternative. Obviously the thought of pollution and strong currents was not something that was a worry to these holidaymakers.

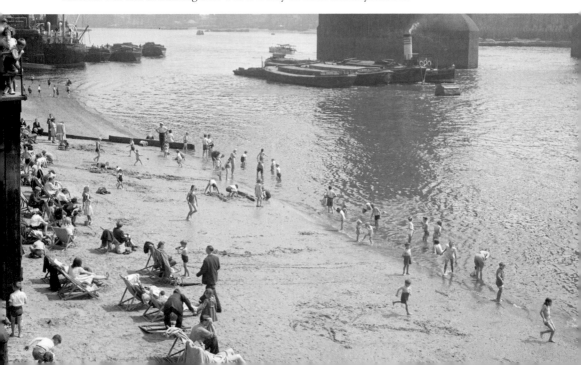

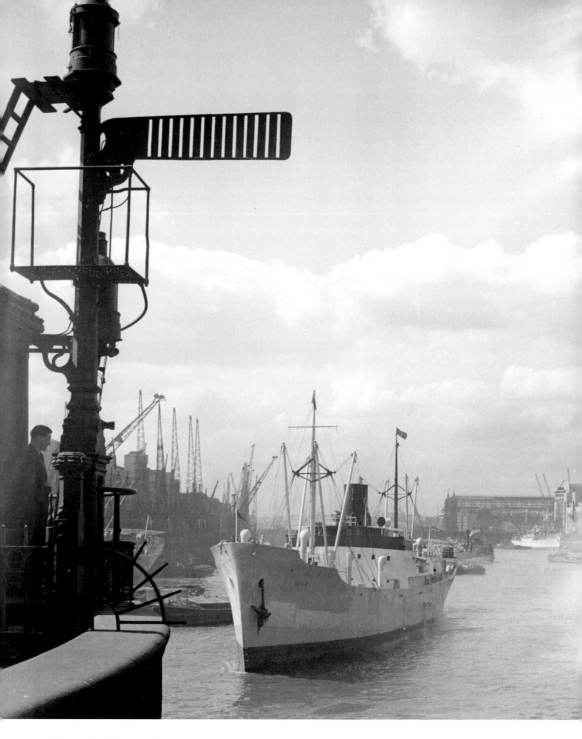

Thames Traffic Signals

The image shows the traffic signals on Tower Bridge, which were used to control movement on the water and on the roads. They were originally semaphore signals but these were replaced in the 1950s. The signals were operated by steam until the 1970s when the reduction in traffic on the river made its use more difficult and they were changed to electrically operated signals.

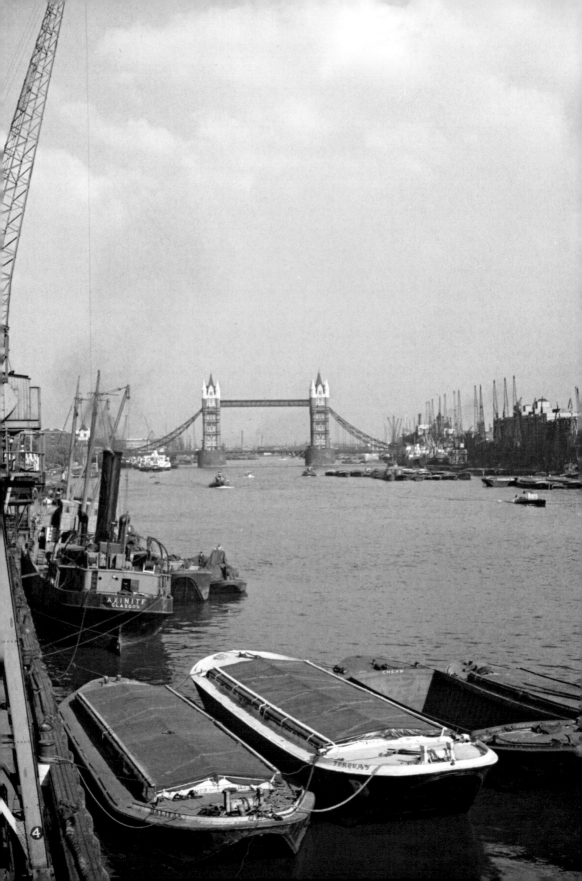

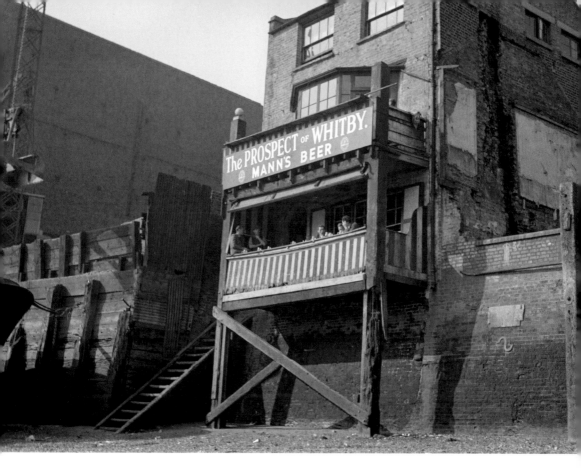

Above: Prospect of Whitby

The Prospect of Whitby public house stands on the banks of the Thames in Wapping. It was originally built in 1520 and was known as the Devil's Tavern. Its clientele consisted of thieves and smugglers, which the East End of the time abounded in. It became the Prospect of Whitby in 1777.

Opposite: Fish Wharf

A view of the bridge from Fish Wharf. Billingsgate fish market dates back to the sixteenth century but the Billingsgate building was built in 1850. The market was moved to the Isle of Dogs in 1982 and the old building is now the site of restaurants and halls, which are used to promote numerous events.

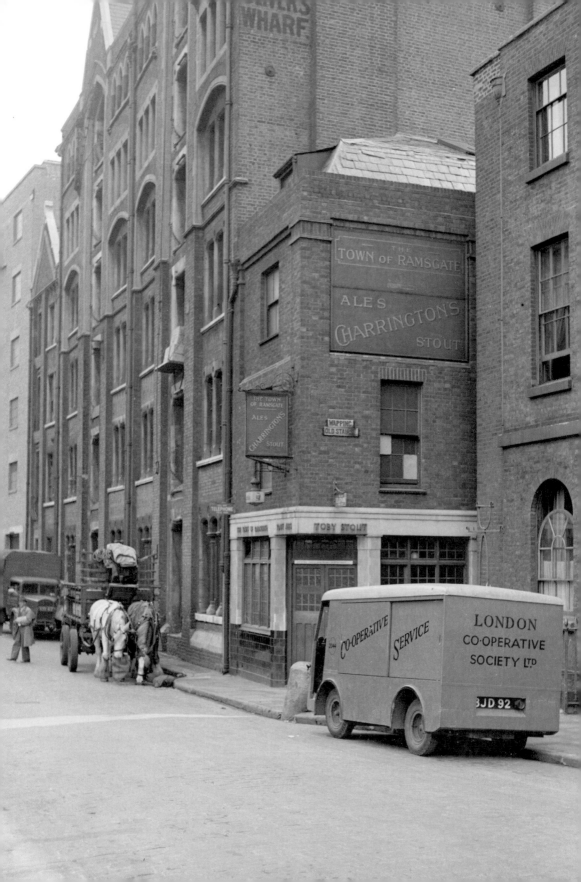

Above: Thames Boatbuilding
A boatbuilders' yard at Limehouse Reach. The buildings are the rears of the houses in Narrow Street. The Thames was a major site not only of docks but also of shipbuilding from medieval times up to the late nineteenth and early twentieth century. There were also numerous smaller boatyards such as the one shown.

Opposite: Wapping High Street
Wapping High Street is shown close to the Town of Ramsgate public house, which dates back to 1758 – although it is believed that an older inn once stood on the site. The image also shows some of the old warehouses that were built for the docks in the nineteenth century. These buildings often replaced terrible slum dwellings.

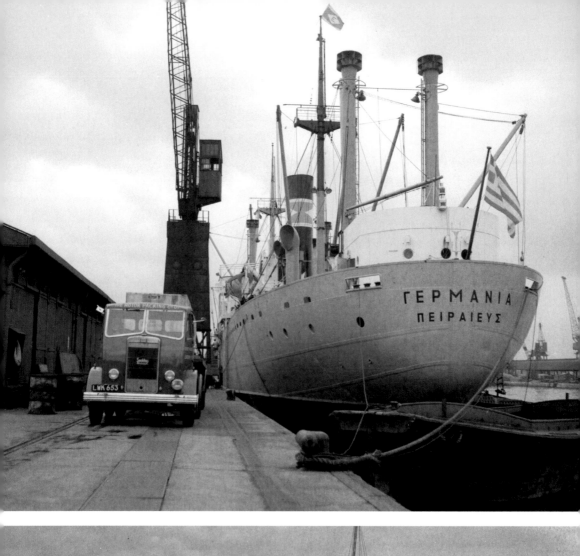

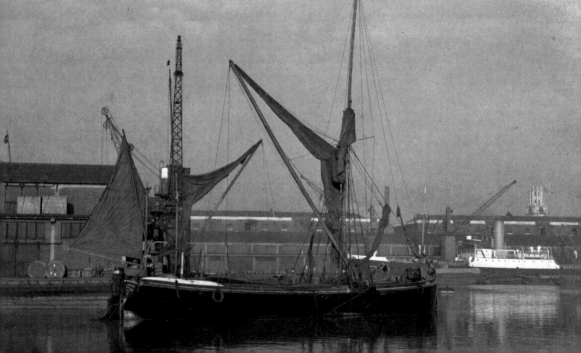

Above: Dock Warehouses
Many parts of the Thames along both banks were lined with buildings such as the ones in the image. They were often warehouses that held large amounts of goods that came in on the ships before being moved around London or to other parts of the country. Many became derelict after the docks began to close in the 1960s and 1970s.

Opposite above: West India Dock
A ship moored in the West India Dock, which opened in 1802. The dock was built mainly due to Robert Milligan, a West Indies merchant, and was surrounded by a wall due to the high level of theft that occurred in the docks before this. Some of the old cranes have survived alongside the modern buildings that now dominate the area.

Opposite below: Thames Barges
An image of a Thames sailing barge moored in the western dock at Stepney. These barges were a common site on the Thames, carrying various loads. They had flat bottoms and were perfect for use in the Thames Estuary. They are still common in places such as Malden in Essex but are seen less frequently on the Thames today.

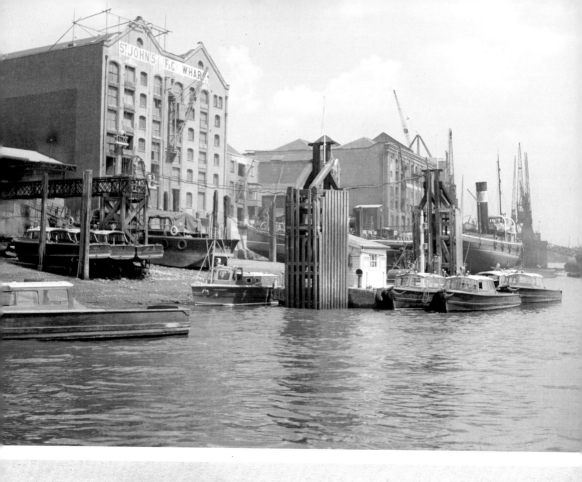

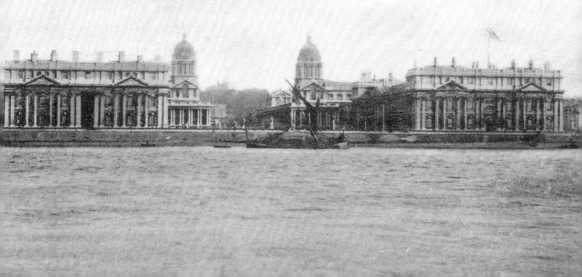

Greenwich College from River

Greenwic

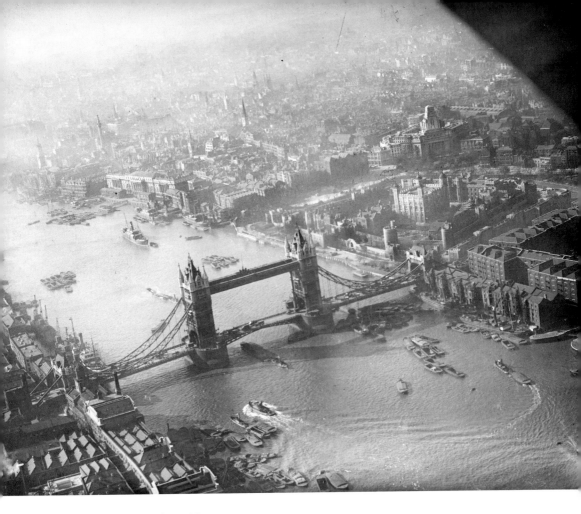

Above: Tower Bridge from Above
An aerial view of Tower Bridge and the docks looking from the south. The number of ships on the river and the lack of any of the high modern buildings that now line the area along the Thames show that it is an old image. The area to the left of the bridge is where the London Mayor's building now stands on open ground, but was still covered in old dock buildings when this was taken.

Opposite above: St John's Wharf
The image shows St John's Wharf in Wapping. There is a police launch moored there. The Thames Police were set up in 1798 to stop crime on the river, including at the docks, and was one of the first police forces to exist. St John's Wharf closed in the 1970s but some of the buildings survived as flats.

Opposite below: Island Gardens
The view from Island Gardens looking across to the naval buildings of Greenwich. The Greenwich hospital was for sailors and was similar to the Chelsea hospital. It was built in the reign of Charles II and was designed by Christopher Wren. It was in use from 1692–1869 and when Queen Caroline arrived at Greenwich in 1795 she thought all Englishmen had a limb missing.

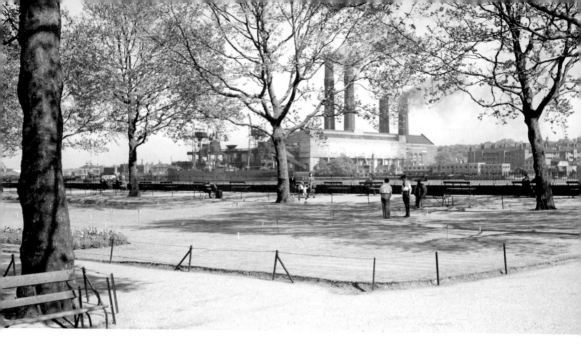

Above: Island Gardens

Island Gardens stand at the tip of the Isle of Dogs with views across the river to Greenwich. It is also the site of the Greenwich foot tunnel, opened in 1902 to replace one of the many ferries that used to cross the river carrying dockers to work. The gardens have been used in the past by a number of artists painting the view across to Greenwich.

Below: Limehouse Basin

The images shows the riverbank near Limehouse Basin. It also shows the Grapes public house, which dates back more than 500 years and still stands in Narrow Street. Sir Walter Raleigh set sail on one of his voyages to the New World from here and the Grapes was mentioned in *Our Mutual Friend* by Dickens, although, as was normal with Dickens, he changed the name.

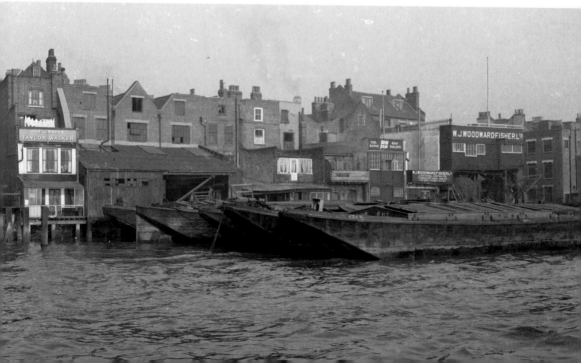

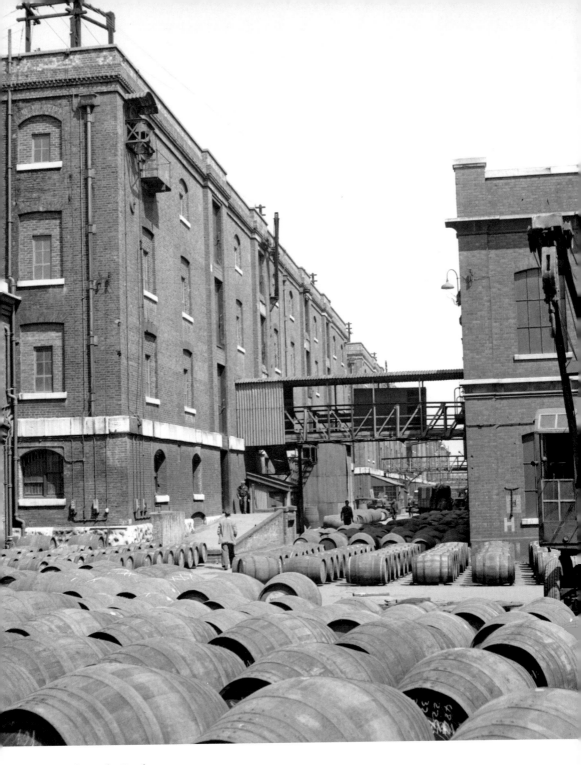

Drinks at the Docks
It wasn't only food that arrived at the docks at Limehouse. These are barrels of Sandman Port waiting for inspection for tax before the contents were bottled.

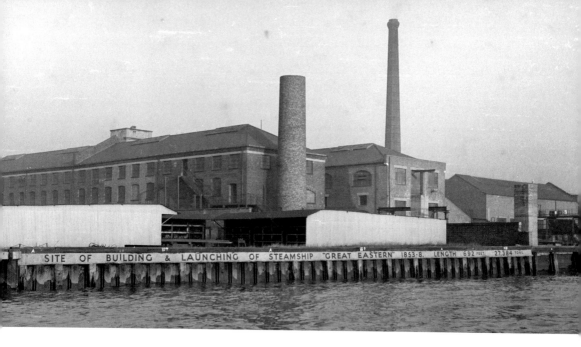

Above: Millwall Shipbuilding

One of the largest shipyards on the Thames was at Millwall where the *Great Eastern* was built in 1858. It was at that time the largest ship in the world and was designed by Isambard Kingdom Brunel. It was used to lay the first transatlantic cable in 1866. Shipbuilding on the Thames declined in the late nineteenth century.

Below: Regent's Canal from Green Street

A view of Regent's Canal from the bridge in Green Street. The canal was first proposed in 1802 and built a few years later as a link between the Grand Junction Canal at Paddington with the River Thames at Limehouse. It runs alongside Regent's Park, which is where it gets its name.

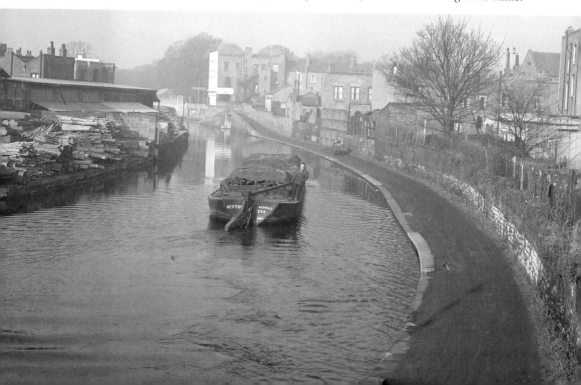

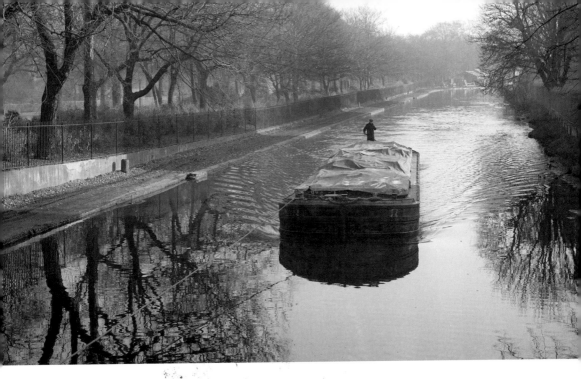

The Canal in Victoria Park

Another view of the Regent's Canal as it passes through Victoria Park in Hackney. The canal was used to carry goods away from the docks on barges like the one shown. Some of the goods were dangerous and in 1874 one of a string of barges being towed by a tug was carrying gunpowder. It blew up as it passed Regent's Park, an explosion heard over most of the city and frightening the animals in the zoo.

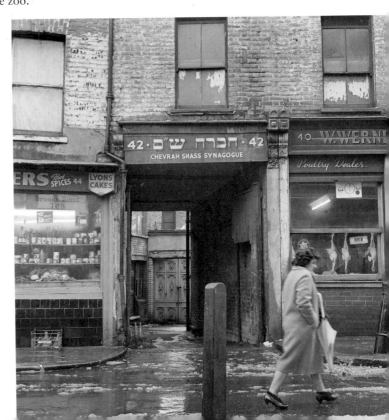

East End Immigrants

The Chevrah Shass Synagogue was situated in Old Montague Street from the end of the nineteenth century until the 1950s. The area around it was once a very strong Jewish area and many of the markets such as those in Brick lane and in Petticoat Lane were dominated by Jewish stallholders.

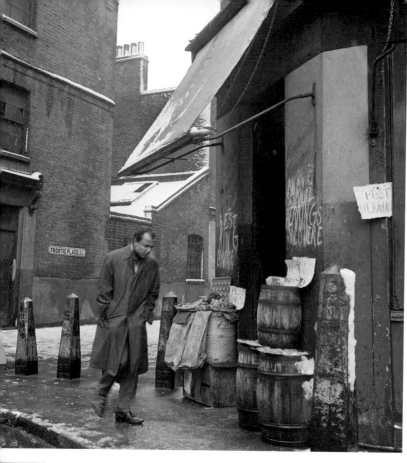

London's Old Shops

An old shop in Frostic Place, E1, after the Second World War. The shop has barrels of herring outside, which would point to the strong immigrant community in the area, which continues to this day. However, the Jewish community has now mainly been replaced by Asians. It is a typical example of a shop of the old East End that has now mainly disappeared.

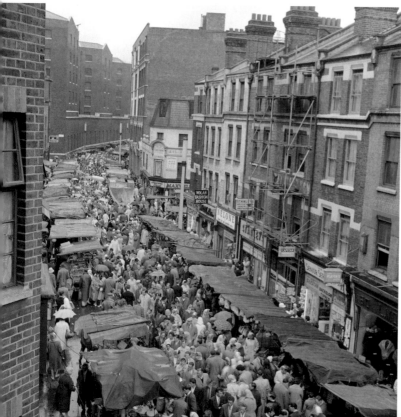

Petticoat Lane

The packed Petticoat Lane Market, which was always at its busiest on a Sunday morning due to many of the stallholders being Jewish and Sunday not being their Sabbath. The market dates back to medieval times and the area became known for the manufacture of clothing. Before the Jews arrived in number the area was populated by large numbers of Huguenots .

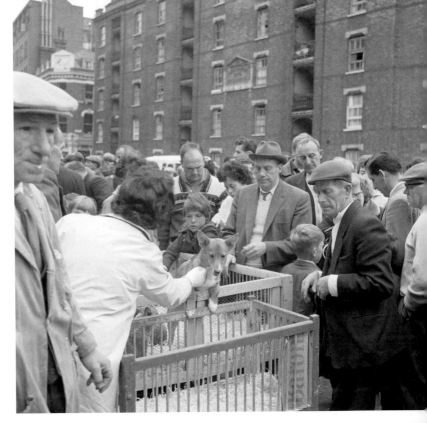

Bethnal Green Market
Another local market at the western end of Bethnal Green Road. The image shows that animals were sold there in the past. Selling puppies from children's cots seems to have been quite a common practice. The part of the market shown is just in front of Huntingdon Buildings.

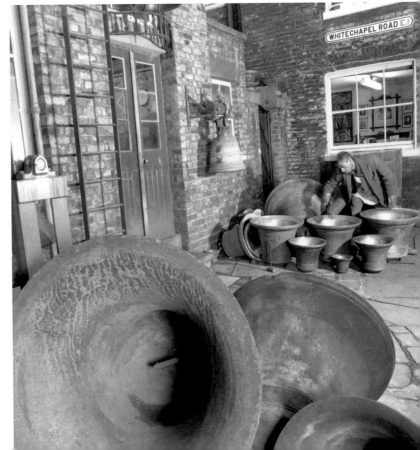

Whitechapel Bell Foundry
The interior of Whitechapel Bell Foundry. The foundry began life in 1570 and produced some of the world's most famous bells such as Big Ben and the Liberty Bell. During the Second World War munitions were made at the foundry.

Left: Victory Bridge
Looking over Victory Bridge towards Ben Johnson Road. The bridge is situated on the Regent's Canal, although the original bridge has been replaced and is now near the Ragged School Museum. The image also shows the Victory public house.

Below: John Bull Public House
The John Bull public house, Roman Road, Bow, shown at the end of the nineteenth century. The man standing in the doorway is probably the landlord. Going by later photos of the pub, I suspect it was later rebuilt and has now closed.

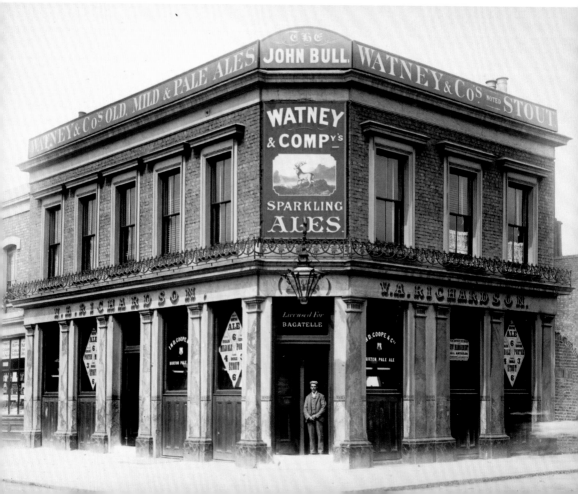

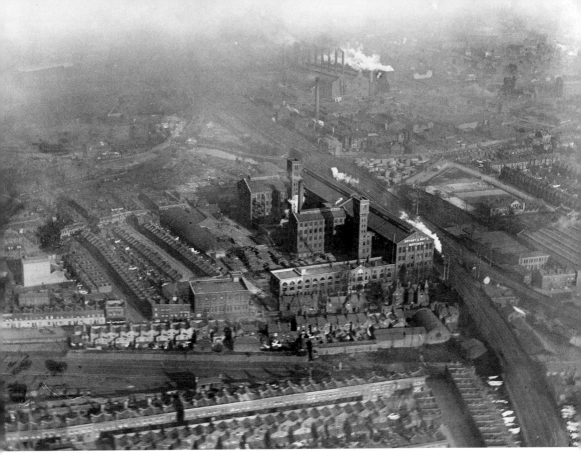

Bryant and May from Above

An aerial view of the old Bryant and May match factory in Bow. The factory was the scene of one of the worst industrial injury cases of the nineteenth century when the girls working there caught a disease known as Phossy Jaw from the chemicals they used to make matches. It was also the site of the famous matchgirls' strike.

Rotherhithe Tunnel
The construction of
Rotherhithe Tunnel in
1907. The tunnel was not
popular when construction
began as more than 3,000
people had to be moved
from the site. It was built
for horse-drawn and
foot traffic between the
docks on either side of the
river at Limehouse and
Rotherhithe.

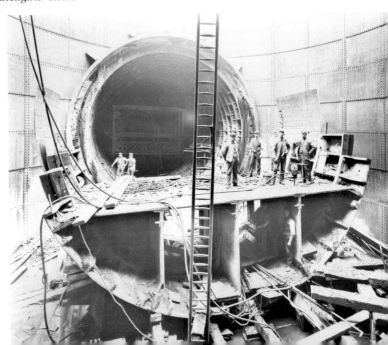

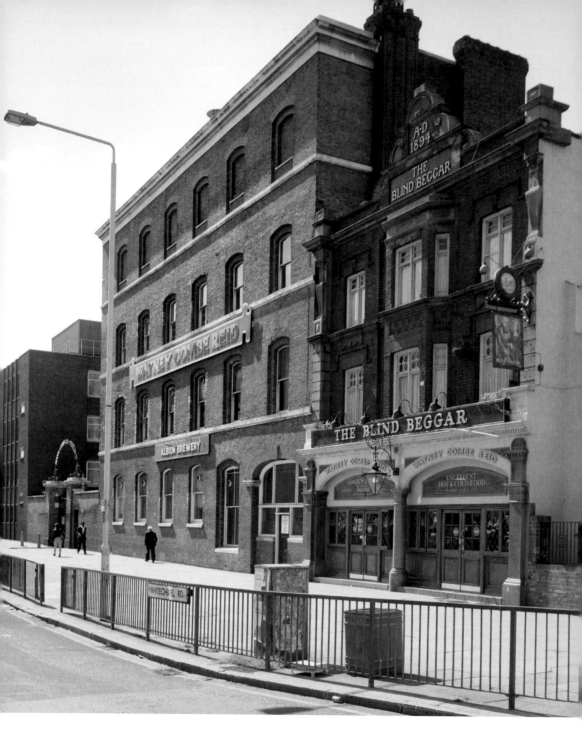

The Blind Beggar

The Blind Beggar public house stands close to the Royal London Hospital in Whitechapel. It was built in 1894 on the site of an earlier inn. It has become one of London's most famous pubs due to a murder carried out by the Kray twins in the pub in 1966 when Ronnie Kray shot George Cornell at the bar.

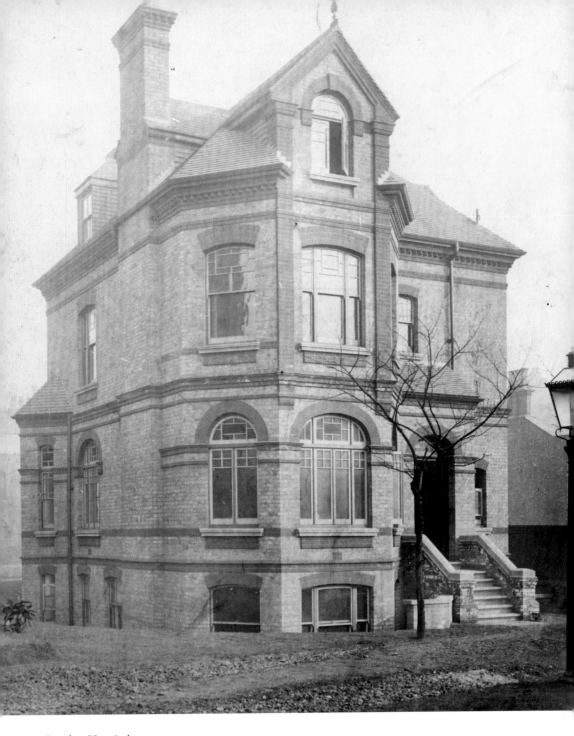

London Hospital
The Chaplin's House at the London Hospital in Whitechapel. The hospital was perhaps best known as the home of Jonathan Merrick, better known as the Elephant Man, in the nineteenth century. The hospital has recently undergone extensive upgrading, although the original building still sits on Whitechapel Road.

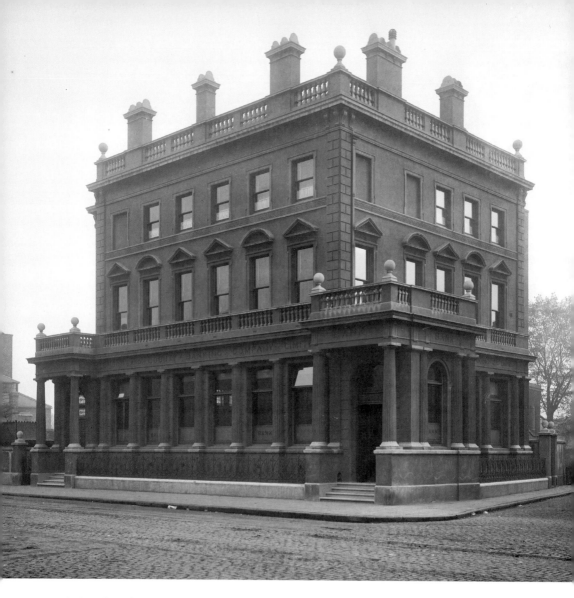

A Grand Bank

The London County Bank on East India Dock Road. In 1890 banks were obviously important buildings, as the opulence of the building shows. East India Dock Road was the site of a number of well-known buildings that still survive, such as the Sailors' Palace, an old sailors' home now converted into flats.

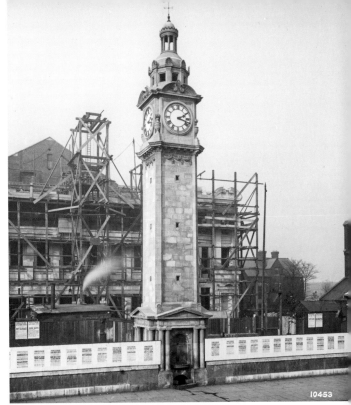

People's Palace
The clock tower at the People's Palace in Mile End Road. The building opened in the nineteenth century for local people and included a great hall, swimming pool and a winter garden and library. It is now part of the Queen Mary University.

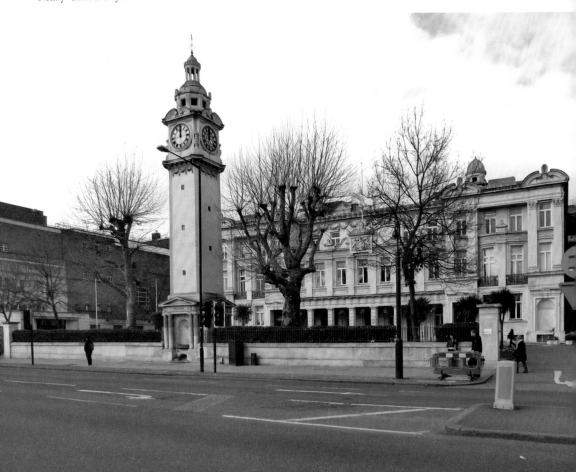

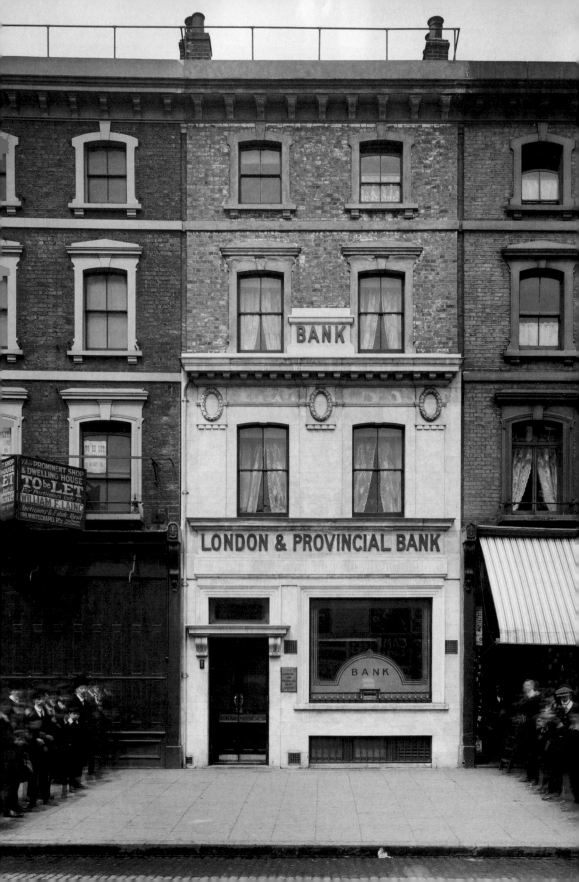

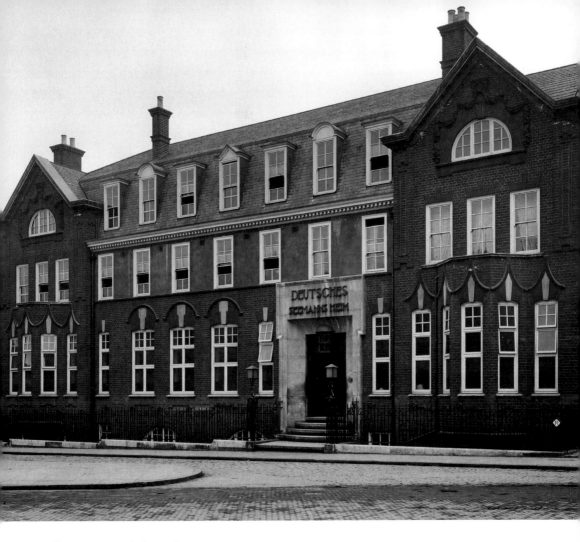

Above: German Sailors' Home
As well as the Sailors' Palace there was another sailors' home in East India Dock Road. This was called the German Sailors' Home before the First World War. I suspect that the name was changed after the war broke out due to strong anti-German feeling in the East End.

Opposite: Another Grand Bank
The London and Provincial Bank stood at No. 167 Whitechapel Road. Many of the old buildings survive to this day, although many of them have seen better days. Huge public investment took place in Whitechapel with the High Street 2012 scheme.

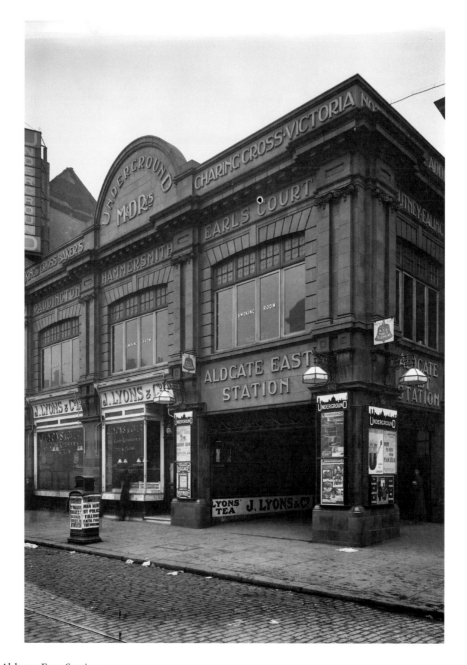

Aldgate East Station

Aldgate East station opened in 1884 as part of the extension of the District line to the east. It was originally going to be called Commercial Road station and was closer to Aldgate station than the present station is. The original name change was not the only attempt at altering the name: in 2012 a local councillor tried to get support for it to be changed to Brick Lane station.

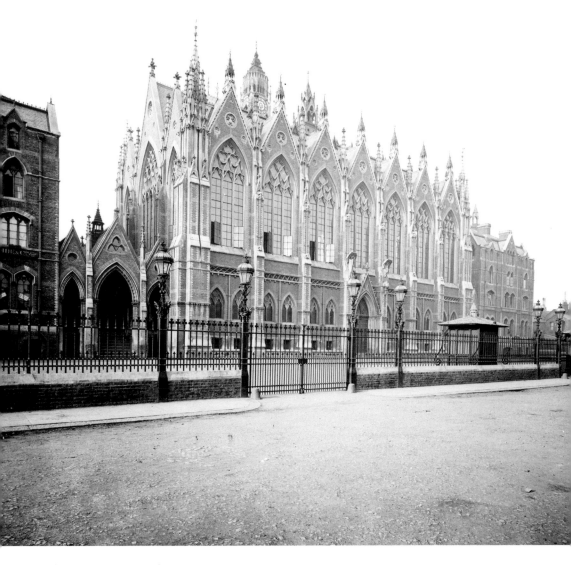

Above: Columbia Market

Columbia Market was built on the site of what had once been a brickfield but then became covered in slum housing. The market began in 1869, which was covered and had 400 stalls selling food. It then closed in 1886 and the building was used as a warehouse. It was demolished in 1958 but a flower market now operates on the site.

Hackney

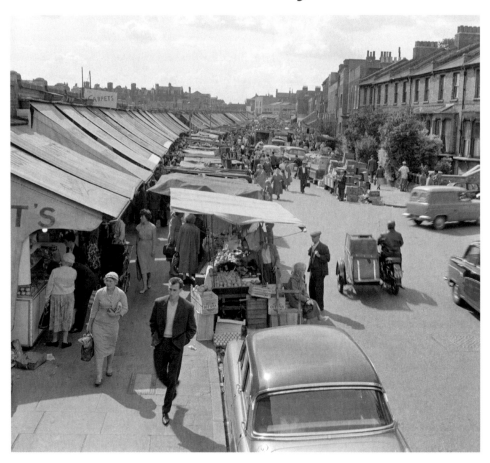

Above: Ridley Road Market
Ridley Road Market in Dalston is another of the East End's thriving street markets. Originally dating from the 1880s and consisting of around twenty stalls, it now numbers more than 150. It is close to Dalston Kingsland Road station on a pedestrianised site and sells a range of multicultural goods on a daily basis.

Opposite above: Shoreditch
Where the name Shoreditch originates from is debatable. One idea is that it was from Jane Shore, the mistress of Edward lV who was buried in a ditch in the area. It was called Shoreditch before her and the name may originate from Sewer Ditch, which is connected to the River Walbrook. It is more likely to have originated from the name of a lord of the manor in the distant past.

Opposite below: Shepherdess Walk
The image of Shepherdess Walk shows the old houses that stood in the area. There was a new estate built there in 1919, which is sometimes called Murray Grove but is actually Shepherdess Walk estate. A large building by the canal is called Canal Building and has been converted to luxury flats overlooking the Regent's Canal.

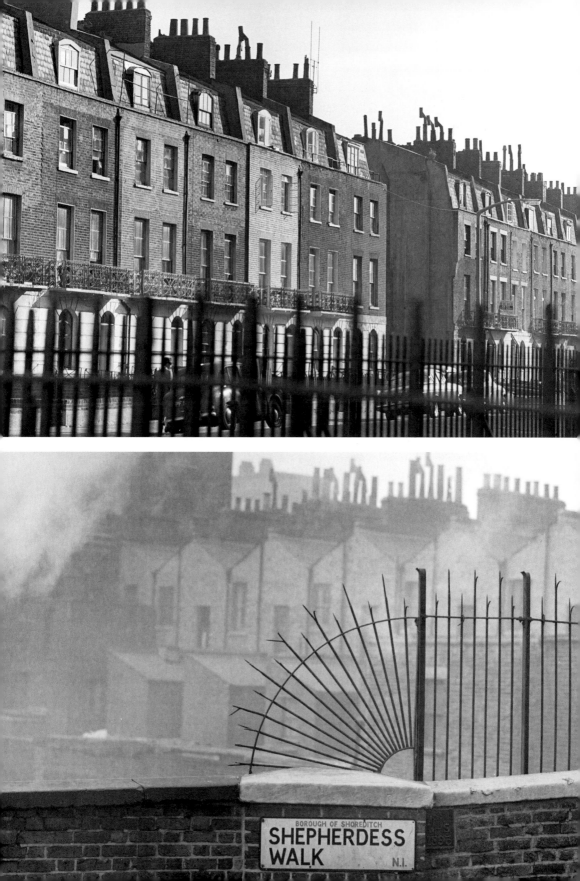

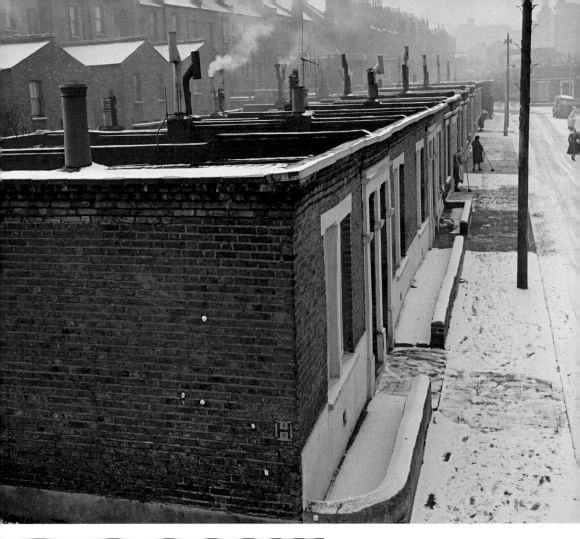

Above: Hackney Homes
The image of Hackney shows, along with the previous two images, how the buildings in the area varied – from large three- or four-storey dwellings down to the single-storey homes shown. Many of the older buildings have survived alongside new modern buildings and older upgraded homes.

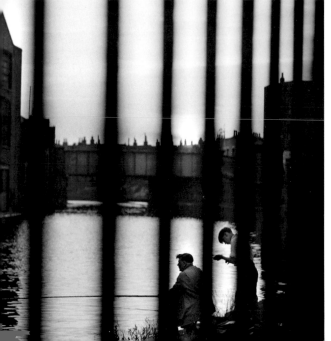

Left: Hoxton
The view of the canal in Hoxton shows how what was once a working route for carrying goods to and from the docks has now evolved into a resource mainly used for leisure activities. Some of the old industrial buildings along its banks are now modern homes.

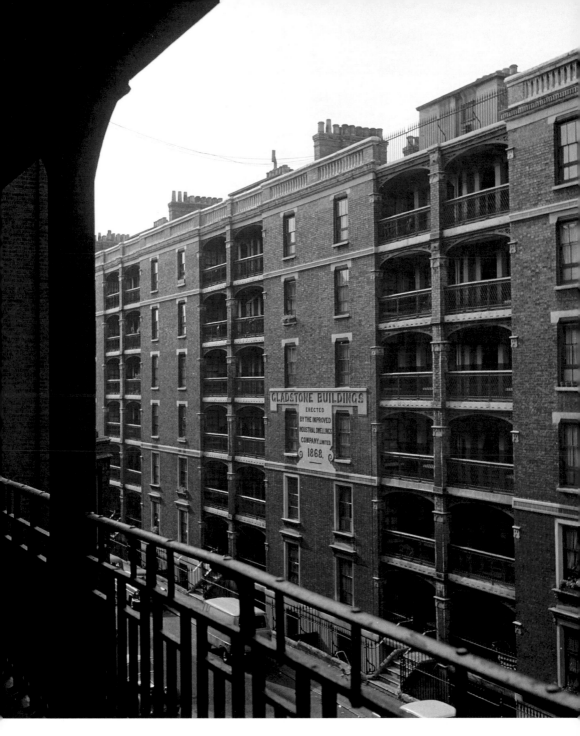

Gladstone Buildings
Gladstone Buildings in Willow Street were built in 1868. There was a great deal of building going on in the area in the mid-to-late nineteenth century, much of the building being done on what was then open land.

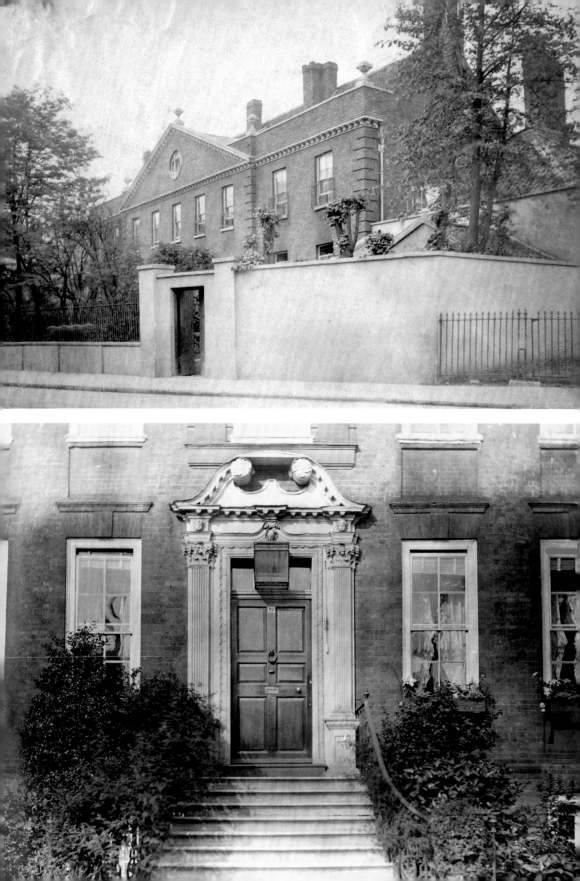

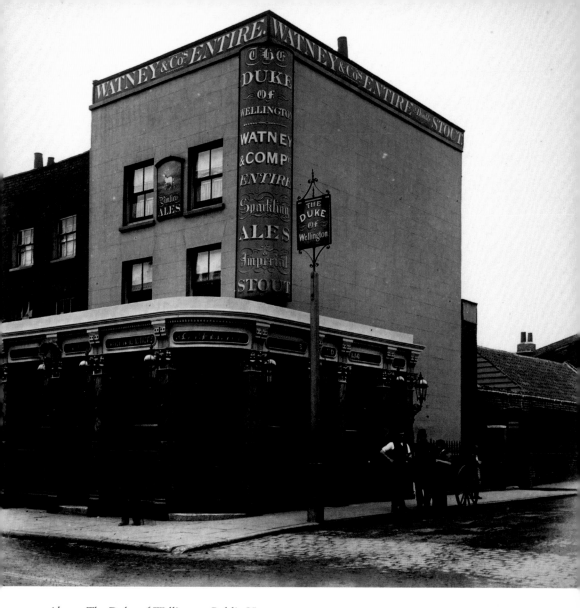

Above: The Duke of Wellington Public House
The image shows the Duke of Wellington public house in the 1880s. An inn stood on the site in the Balls Pond Road since 1842. Pubs named after people from the Napoleonic wars, such as Wellington and Nelson, were popular in the early nineteenth century.

Opposite above: Brooke House
Brooke House in Hackney dates back as far as Tudor times and was once owned by friends of Henry VIII. In 1758 it became a private mental asylum. The house was badly damaged by enemy bombing during the Second World War and part of the building was demolished in the 1950s.

Opposite below: British Asylum for Deaf and Dumb Females
The image shows the doorway of the British Asylum for Deaf and Dumb Females. The asylum moved to this building in 1864 and took girls aged ten years and over, who were then taught dressmaking and laundry skills. The house was purchased by the council in 1933 and demolished to make way for flats.

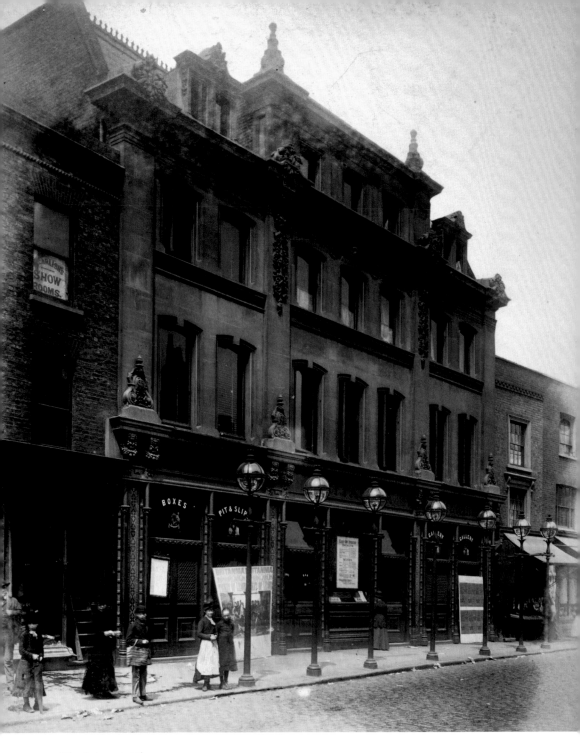

The Britannia Theatre
The Britannia Theatre stood in Hoxton Road from 1841 to 1900. It put on varied performances ranging from music hall to serious plays such as Shakespearean ones. It was destroyed by fire in 1900 and later became a Gaumont Cinema in 1913, until this was also destroyed in 1940.

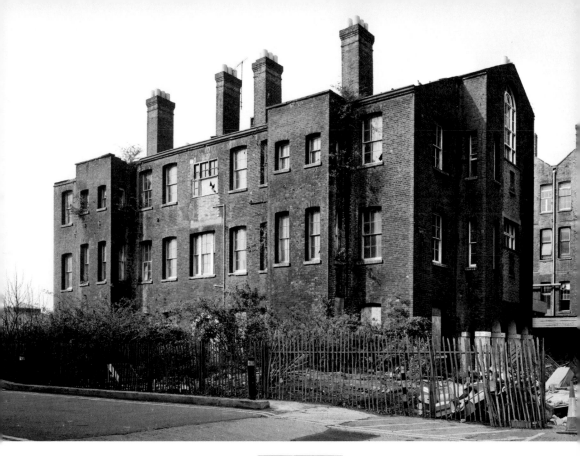

Above: St Leonard's Hospital
St Leonard's Hospital was built between 1863 and 1866 as Shoreditch Workhouse to replace an earlier building that had become squalid. An infirmary was added in 1890 and these were separate buildings until the workhouse closed in 1930 and when the whole site became a hospital, which is still in use today.

Right: Hackney Workhouse
Hackney Workhouse was in Homerton High Street and opened in 1728 for fifteen paupers. It was extended in 1741 to take thirty paupers and by 1750 also took the insane. As the population of Hackney expanded in the nineteenth century more space was needed and a new workhouse was built in 1841. This building became Hackney Hospital.

Above: New River Pumping Station

The image may look like a castle but is in fact the New River Pumping Station, Green Lanes. When it was built in 1852–56 the area was still mainly open countryside and it was thought an industrial building would not be well received. Therefore, £81,000 was spent building it.

Opposite above: Catherine Street School

The Catherine Street Board School, shown in 1887 with the children and teachers, was designed by Thomas Jerram Bailey for the School Board of London. It stood in Catherine Street but this was later changed to Cranwood Street. It is typical of the schools of the time.

Opposite below: New Fairfield Works

The image shows the New Fairfield Works in Tynte Street, Homerton. The building was designed by W. G. Shoebridge. Tynte Street later became Kenworthy Road. I suspect the works may have some connection to the Fairfield Works of Bryant and May in Bow.

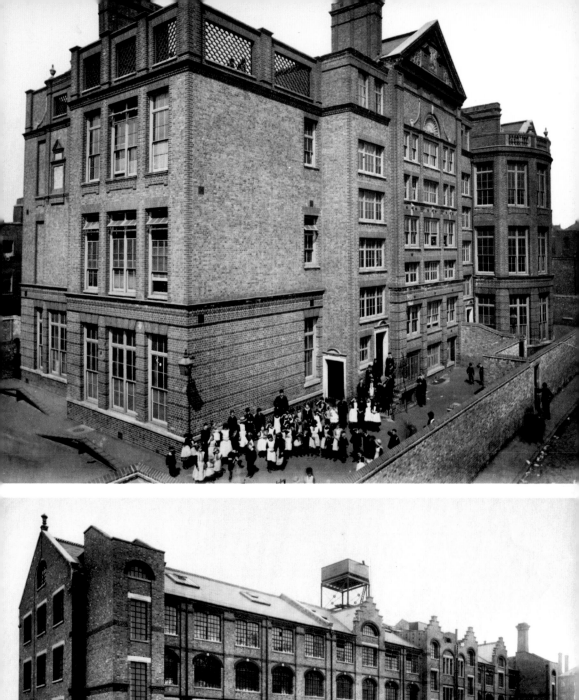
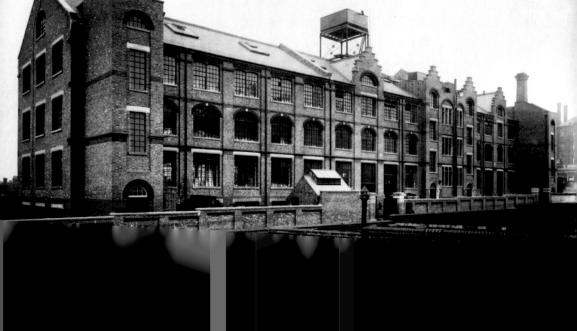

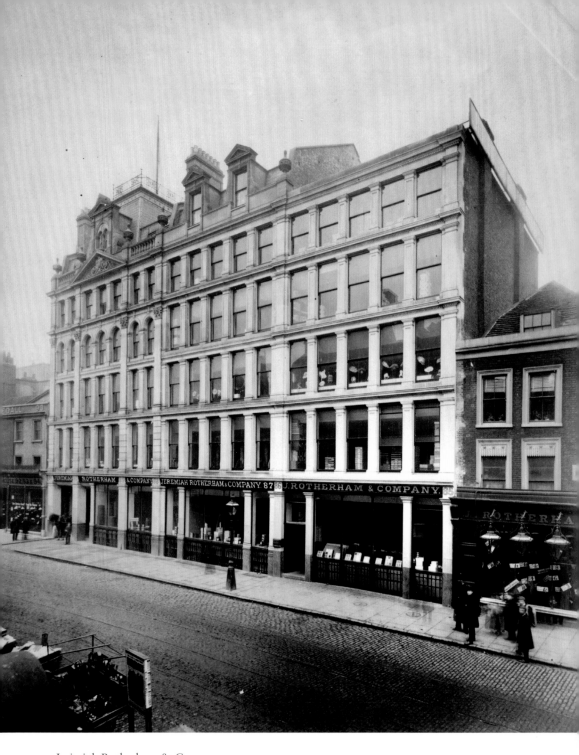

Jerimiah Rotherham & Co.
Jerimiah Rotherham & Co. of Shoreditch High Street was a draper's shop that evolved into a department store. It is shown in 1894 and sold a wide range of textile products. The building was destroyed by bombing in the Second World War.

Right: John Carter & Sons
An image of John Carter & Sons
boot and shoe manufacturer of
No. 64 Kingsland Road, Hackney.
The photograph was taken in 1912
before the First World War. Factories
in the early twentieth century were
often positioned on streets such as this,
whereas they later seemed to have been
moved into separate industrial estates.

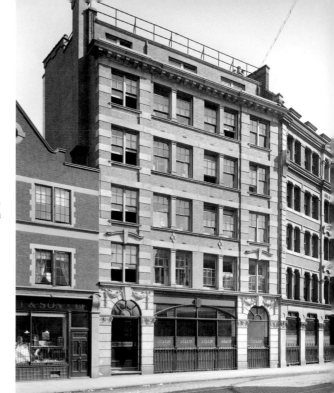

Below: Celebrating Victory
A later photograph of Jerimiah
Rotherham & Co. Ltd of Shoreditch
High Street. This one was taken
in 1919 and shows the building
decorated with flags and bunting
saying victory, peace, unity and
progress. It was no doubt celebrating
the end of the First World War in
late 1918.

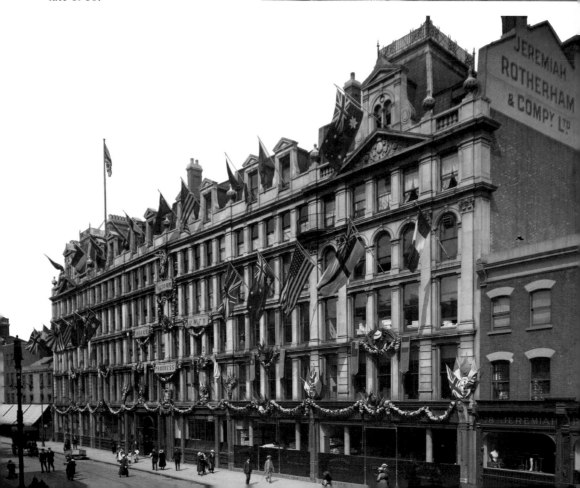

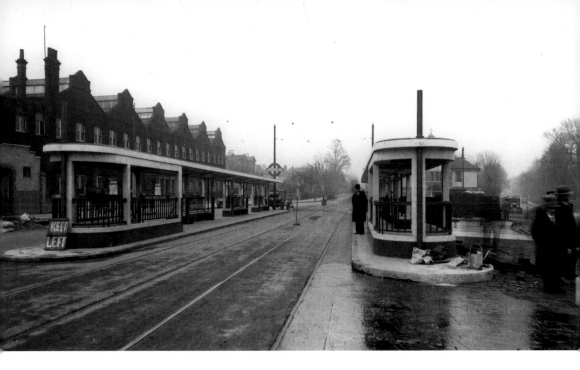

Above: Manor House Station

Manor House station was named after a local public house and opened in 1932. It had a number of exits including one that led directly to tram routes. The trams stopped running in 1938 and were replaced by trolleybuses. Some of the exits were then closed in the 1950s.

Below: Lea Bridge

A view from the Lea Bridge in Lea Bridge Road in the late nineteenth century. The area is now much more built up and the waterworks close to the site played a significant role in the development of London's water supply.

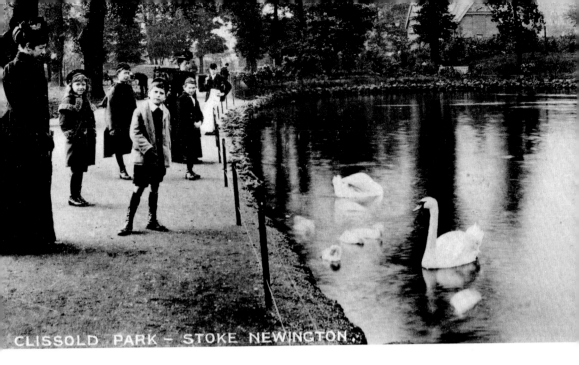

CLISSOLD PARK – STOKE NEWINGTON.

Above: Clissold Park
Clissold Park was once a private estate that was bought by the local council in 1887 for £96,000. This was mainly due to the efforts of Joseph Beck and John Runtz and the lakes in the park have been named after them. The park opened to the public in 1889 and had boats and a railway by the 1920s.

Below: Victoria Park
Victoria Park in Hackney is one of the large green spaces that still exist in East London. It was created in 1884 and has a fountain that was erected due to the kindness of Angela Burdett-Coutts in honour of Queen Victoria. The fountain provided local people with drinking water and cost £6,000. The photo shows the boating lake in the early twentieth century.

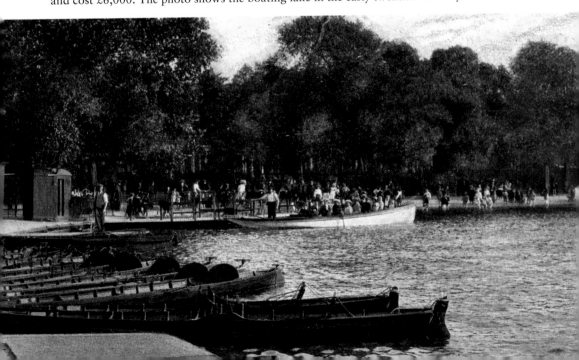

Southwark

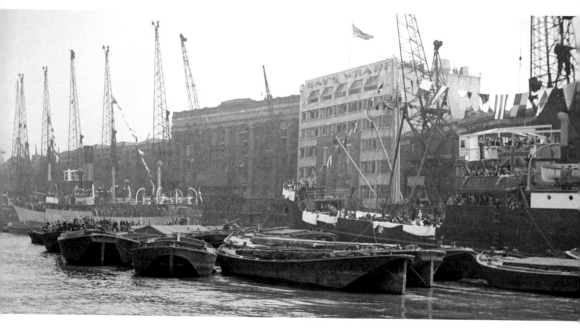

Hay's Wharf
The photograph shows Hay's Wharf in the Pool of London just before the Second World War. It shows how far it stretched along the south bank of the river with cranes along its length ready to unload the food that arrived there daily.

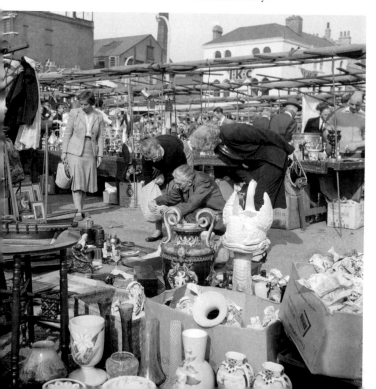

Bermondsey Antique Market
Bermondsey Antique Market began in 1855 and was known as a place where you could trade with impunity, in that any stolen items sold there did not have to be returned. It is also known as the New Caledonian Market and is based in Bermondsey Square, once the site of an abbey.

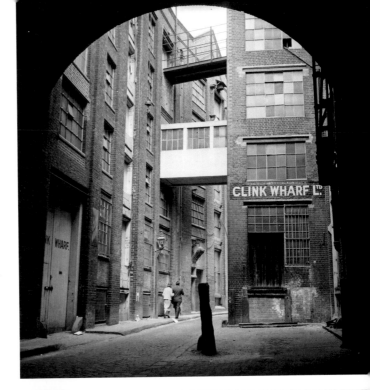

Clink Wharf

Clink Wharf got its name from the Clink Prison that once stood there. It was where the slang term 'in the clink', for being in prison, came from. It was burnt down after a riot in 1780. The buildings that have survived there are now converted into luxury homes.

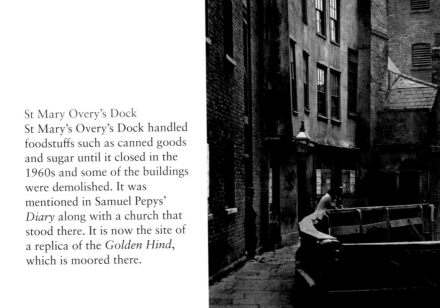

St Mary Overy's Dock

St Mary's Overy's Dock handled foodstuffs such as canned goods and sugar until it closed in the 1960s and some of the buildings were demolished. It was mentioned in Samuel Pepys' *Diary* along with a church that stood there. It is now the site of a replica of the *Golden Hind*, which is moored there.

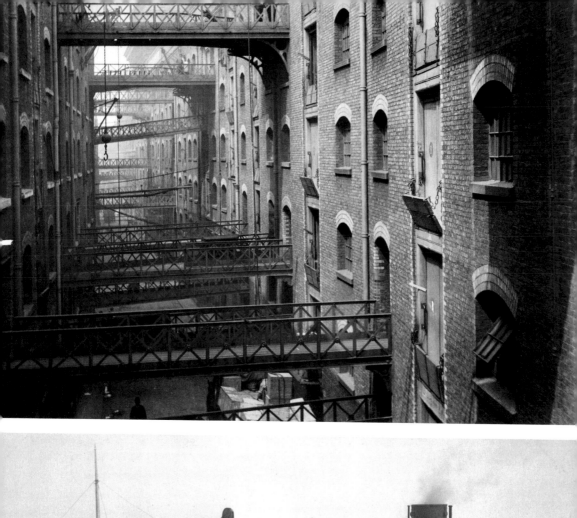
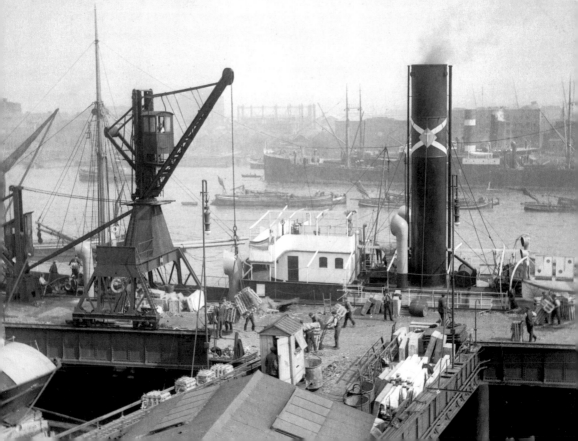

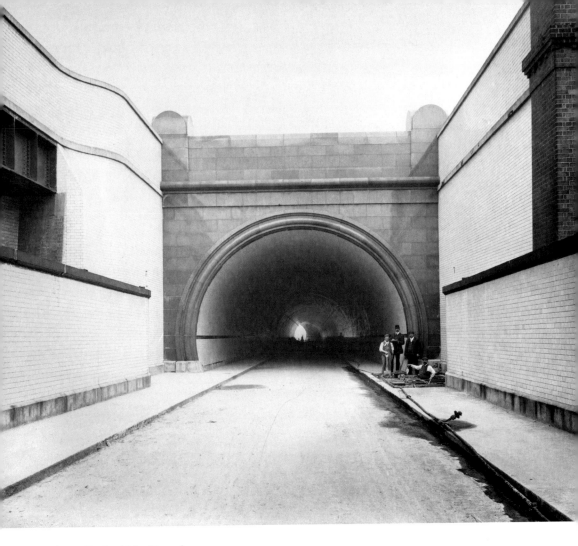

Above: Rotherhithe Tunnel

Rotherhithe Tunnel has narrow lanes as it was built for foot and horse-drawn vehicles. There used to be spiral metal staircases for foot passengers but these have now been closed. The tunnel has a number of bends supposedly to stop horses seeing daylight as they were driven through it.

Opposite above: Shad Thames

Shad Thames ran along the Thames up to Tower Bridge at its west end. Its name is believed to be a corruption of the name of St John's Church that stood nearby but also to be named after the shad fish found in the Thames. The old warehouses are arguably the buildings that best display old docklands, with the bridges connecting facing blocks. They are now, of course, converted into luxury apartments.

Opposite below: Butler's Wharf

Butler's Wharf and warehouses were built in the 1870s and once contained the largest tea warehouse in the world. It closed along with other docks in the area and in the 1970s part of it became a performance art centre. *Doctor Who* was filmed there in 1984, but it is now apartments and restaurants.

Newham

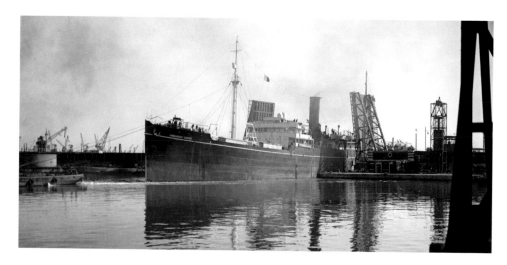

George V Dock

The George V Dock was the last of the Royal Docks to be completed and was also the smallest of the three. It wasn't completed until 1921 despite being started in 1912 – the war interrupted its construction. It is now the site of the London City Airport and the University of East London, which stands on its northern bank.

Royal Victoria Dock

The Royal Victoria Dock opened in 1855. Unlike other docks along the Thames, which were built on the sites of previous dwellings, the Victoria Dock was built on the uninhabited land of Plaistow Marshes. It was built to accommodate large steamships and was the first dock connected to the railway.

Royal Albert Dock
The Royal Albert Dock was opened in 1880 and is larger than the earlier Victoria Dock. It had
an entrance from the Thames at Galleon's Reach. It is now the site of the London City Airport
along with the George V Dock. Some ships still pass through it on their way to the Excel Centre.

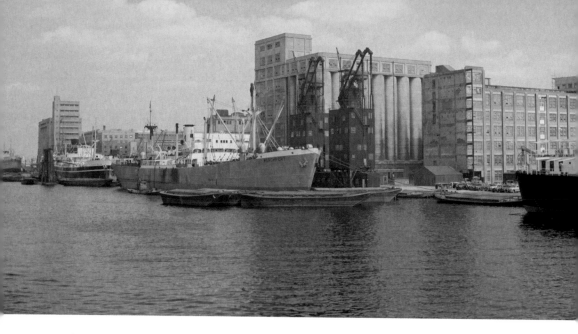

Above: Royal Victoria Dock

The Royal Victoria Dock has now become a tourist attraction in its own right. It has a water sports centre and the nearby Excel Centre, which covers a 100-acre site. The dock is also the site of one end of the Emirates Cable Car that travels across the Thames to the Greenwich Peninsula.

Below: Dock Security

The image shows a group of men being searched by the Port of London Authority Police at gate 8 of the Royal Docks at Custom House. Pilfering at the docks had been a problem since they opened, but this image was taken after the Second World War, so it was obviously still going on.

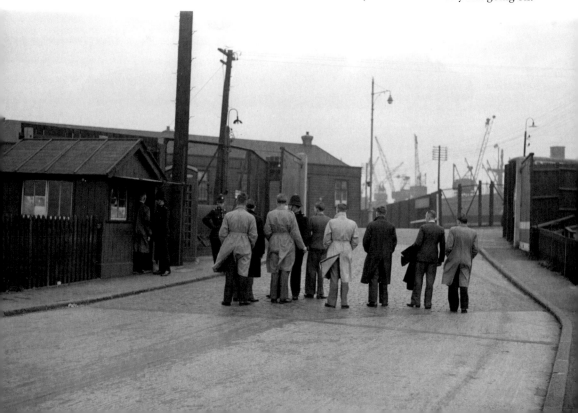

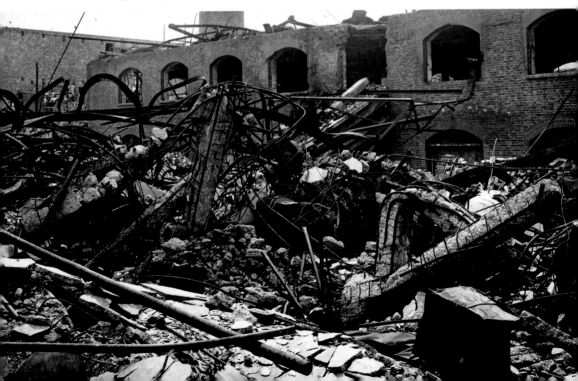

Limehouse from Above
An aerial view of Limehouse showing houses that were probably built for workers at the docks and at other large employers such as Tate and Lyle that once stood there. The area gets its name from the old limekilns used by potters in the Middle Ages. It was also an early port. Limehouse was also the site of the original Chinatown.

Brunner Mond Disater
The Brunner Mond Disaster in January 1917 was one of the many disasters that affected the East End. Brunner Mond was a company producing soda crystals in Limehouse before the war but was forced by the government to produce TNT despite being in a highly populated area. When 50 tons of TNT exploded it destroyed not only the factory but many of the houses around it, killing seventy-three people.

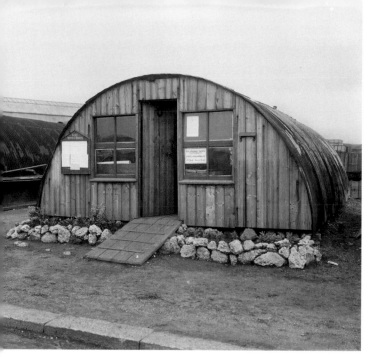

Left: Military Canning Town
Canning Town became the site of
large dumps of military supplies
after the First World War. The
photograph shows a Nissen Hut
in Cody Road in 1919 that was
used to store Royal Engineers
Army Surplus stores.

Below: The Thames from Above
An aerial image of the Thames
in East London showing the
river and the docks where the
river bends. It was taken in
1921. It is hard to pinpoint
exactly where it shows but it
looks like the entrance to the
Bow Creek in the top right-hand
corner.

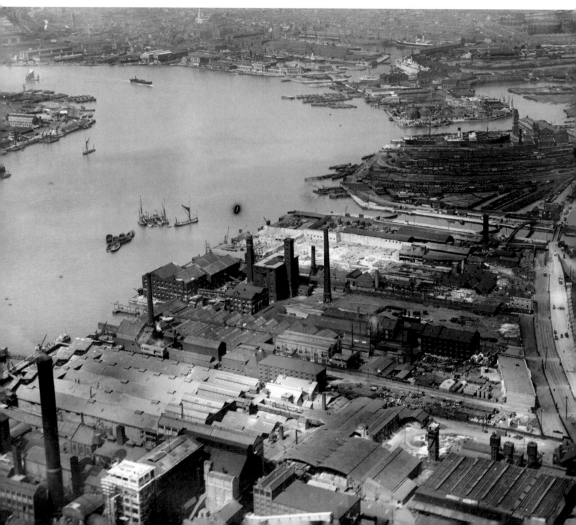

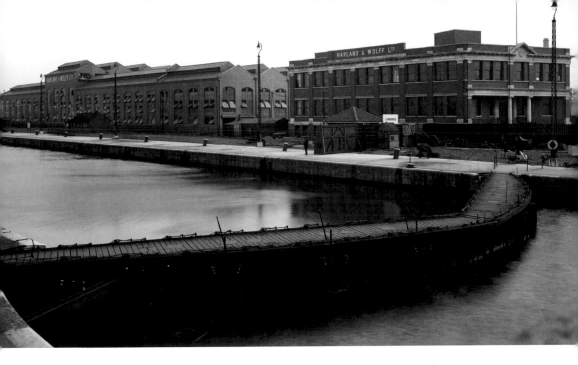

Thames Shipbuilding

The Thames was once a well-known shipbuilding centre, from old wooden warships in the Middle Ages up to the giant ironclads of the early twentieth century, but most of the yards had gone by the First World War. The exception was Harland and Wolff, who had a number of yards on the Thames. The image shows the largest one at North Woolwich in 1923. It lasted up until the 1970s, still producing boats and small ships.

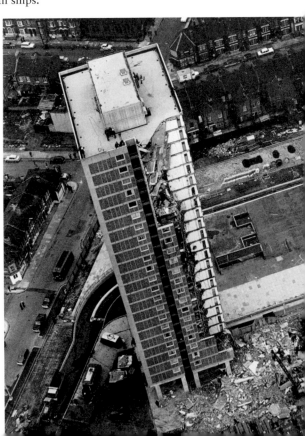

Ronan Point Disaster

This image is a more modern one from 1971 showing Ronan Point, Butchers Road, Canning Town. In May 1968 a gas explosion caused a complete collapse of one corner of the twenty-two-storey tower block. It was amazing that only four people died and seventeen were injured. Although the flats were rebuilt, the event did shake peoples confidence in high-rise buildings.

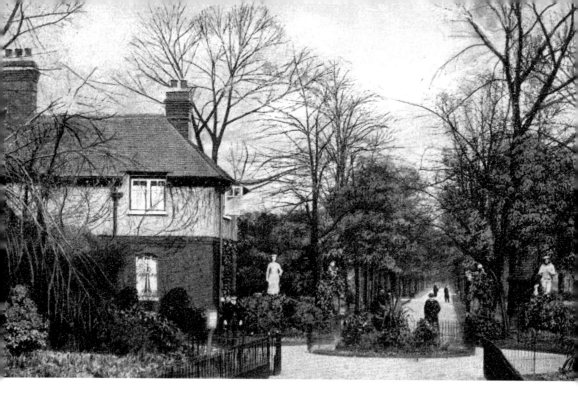

Royal Victoria Gardens
The Royal Victoria Gardens at North Woolwich has an interesting history for a park. It opened in the mid-nineteenth century as a popular entertainment centre with circus acts, dancing and music. Boats carried customers down from London to the park. The gardens had financial problems and the owner, William Holland, escaped from the gardens by hot-air balloon. They reopened as the present gardens in 1890.

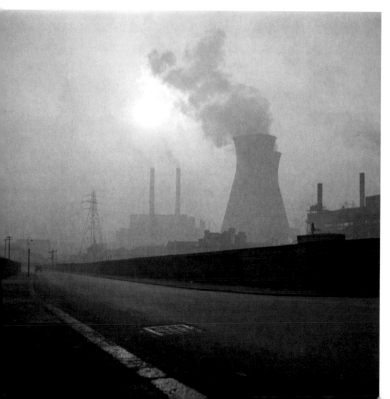

West Ham Power Station
West Ham Power Station opened in 1904 to provide power for the area's trams. It was extended up until 1930 and became London's largest power supplier. The image shows the B power station built in 1951 with the large cooling towers. It closed in 1983 and was demolished soon after.

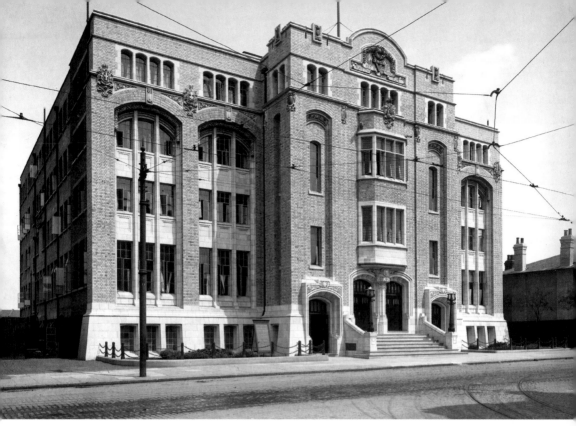

Above: YMCA
The building in the image stands on Greengate Street and was once a YMCA club built just after the First World War. In more recent times it has been used as an annex of the Polytechnic of East London, which later became a university. It has now been converted again into apartments, but despite the changes to the inside of the building the exterior remains the same.

Right: East Ham's Cinema
The Odeon Cinema stood in Barking Road, East Ham, and is shown just before the Second World War. It was built on the site of the Boleyn Electric Theatre in 1910. It closed in 1981 but reopened as the Boleyn Cinema in 1995. It closed again in 2014 and was converted into a banquet hall, while the old balcony was converted into two screens.

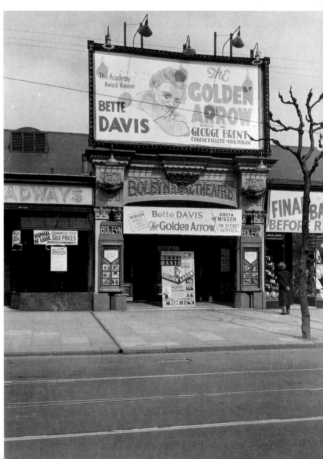

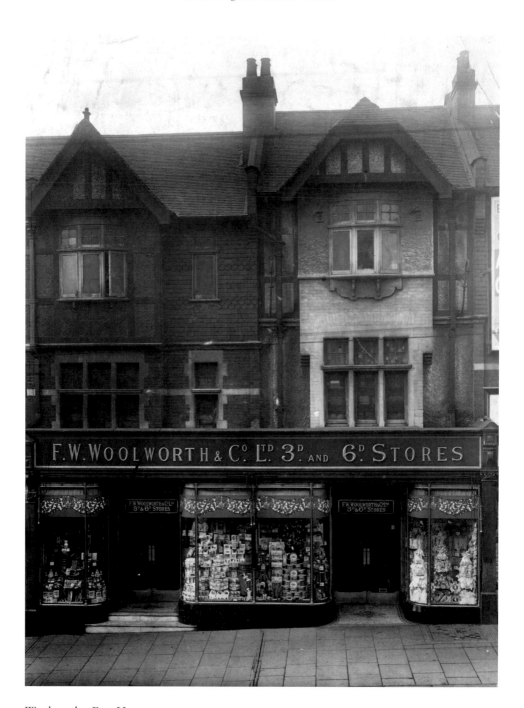

Woolworths, East Ham

Woolworths in East Ham opened in 1920 at No. 193 High Street North opposite the Palace Theatre. It is shown in the photograph before the Second World War. It was bombed and destroyed on the first day of the Blitz in September 1940. It was then rebuilt at Nos 72–76 High Street North.

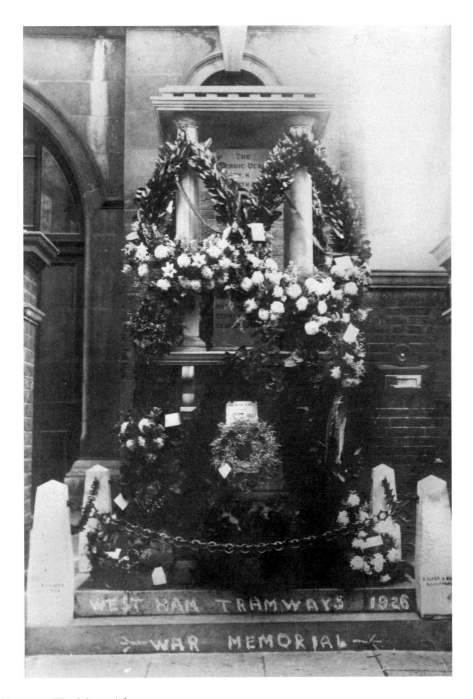

Tramway War Memorial
It was not unusual for large employers to erect memorials to their workers who died in the First
World War. The West Ham Tramway War Memorial was erected outside the Tramway Offices
at No. 90 Greengate Street, Plaistow. The building has since been redeveloped but the memorial
has become a Grade II-listed monument.

STRATFORD PARK

Above: West Ham Park
The land for West Ham Park was obtained by the local council in 1874. The park used to be part of the grounds of Upton House, which at one time belonged to the Gurney family. This included Elizabeth Fry, who lived there and was visited by many members of European royalty who wanted to hear about her prison reform work.

Below: Bisson Road
The image shows houses in Bisson Road, West Ham, which look out over the Three Mills river. There had been mills at the Three Mills since medieval times. They were fed by water from the River Lea and supplied from the Three Mills river. There has been a lot of work carried out on the river in the past few years and it leads into the site of the Olympic Park.

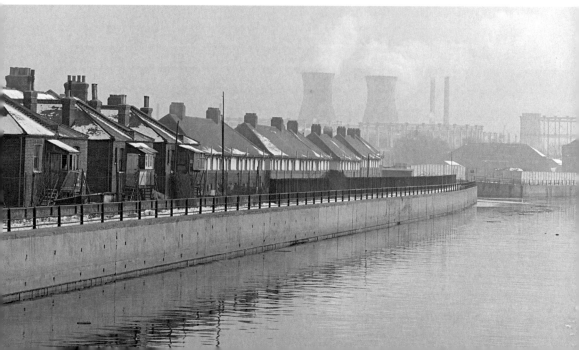

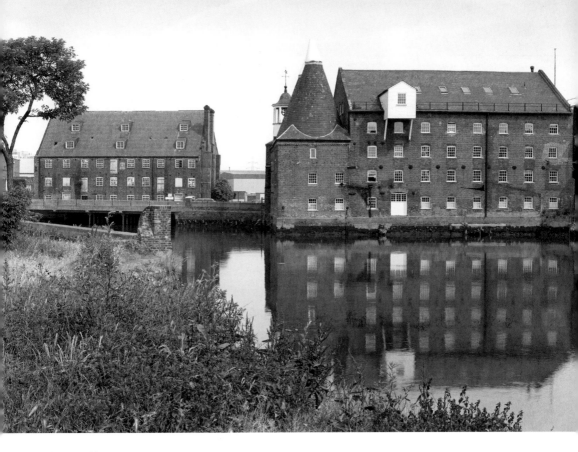

Three Mills

The House Mill at Three Mills in Bow was built in 1776 and is the largest surviving tide mill in the world. It once produced flour for bakers in Stratford and in 1588 there was also a gunpowder mill on the site. In the eighteenth century gin was made there and supplied to the Royal Navy. The mill is now used as an education centre.

Abbey Mills

The Abbey Mills Pumping Station was designed by Joseph Bazalgette and built in 1865. As with other Victorian buildings, it was designed to not look like an industrial building. It was worked by eight beam engines driven by steam and pumped sewage from London's sewers. It was built on the site of a mill owned by Stratford Abbey, from where it got its name.

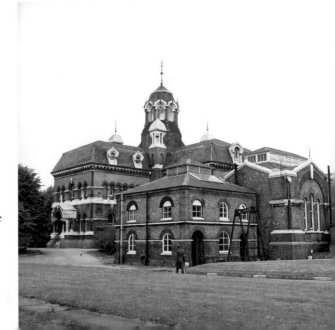

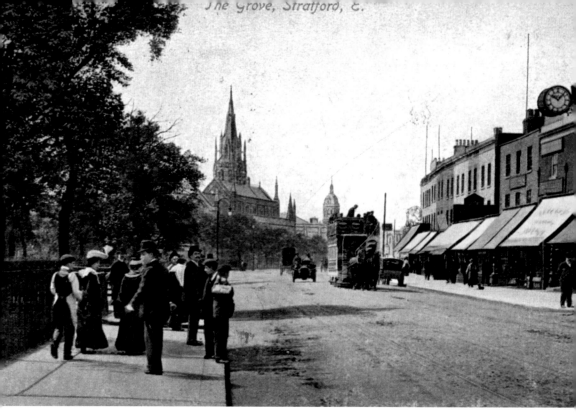

Above: The Grove
The Grove has not changed greatly since the old image was taken although there have been some new buildings. It is in the centre of Stratford with the church in the centre of the photo. The grove was close to the home of the poet Gerard Manley Hopkins and there is now a memorial to him outside the new library.

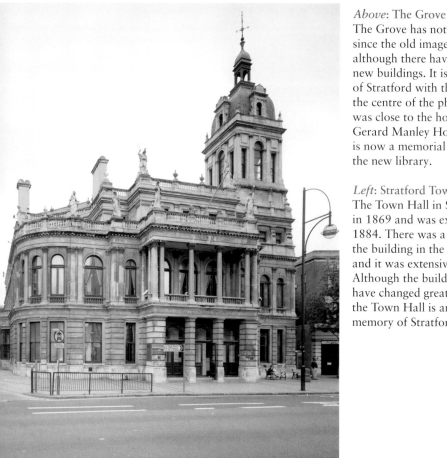

Left: Stratford Town Hall
The Town Hall in Stratford opened in 1869 and was extended in 1884. There was a serious fire in the building in the early 1980s and it was extensively restored. Although the buildings around it have changed greatly over time, the Town Hall is an unchanging memory of Stratford's past.

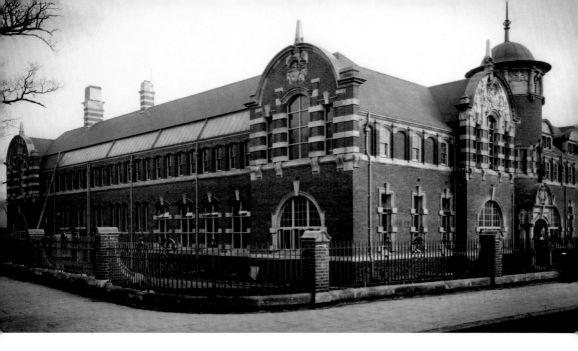

Above: Technical Institute

The Technical Institute in Stratford opened in 1892. Speaking at its opening, John Passmore Edwards, a famous name in the East End, described it as 'a people's university'. His words were to become fact as the building later became part of the University of East London. It has also been a library and the Passmore Edwards Museum.

Below: Yardley Factory

Yardley was a well-known name in soap production in London as early as the seventeenth century. They opened a factory in Carpenters Road, Stratford, in 1905, shown in the photograph. In 1966 they opened a new large factory at Basildon. Part of Carpenters Road and the industrial area around it has now become a part of the Queen Elizabeth Olympic Park and is often crowded with football supporters making their way to the London Stadium nearby.

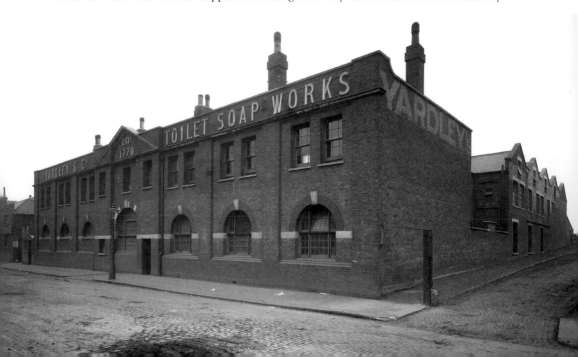

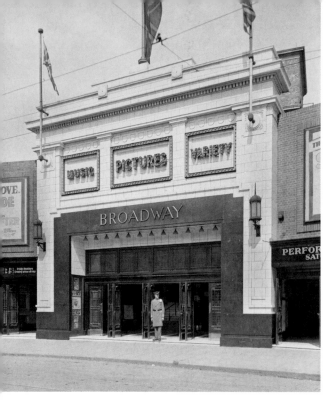

Left: Broadway Cinema
The Broadway Super Cinema in Tramway Avenue, Stratford, opened in 1927. It was owned by Hyams and Gale but was taken over by Gaumont the following year. It was bombed during the war but survived until 1960 when it became a factory. The building was later demolished.

Below: Stratford from Above
An aerial view of Stratford showing the Abbey Mills Sewage Pumping Station in 1923. The area around it is very industrial as Stratford was in the early twentieth century. The twenty-first century has seen a major transformation as many of the factories in the area were demolished to make way for the Olympic Park for the 2012 Olympic Games, which in turn has attracted a number of new apartments.

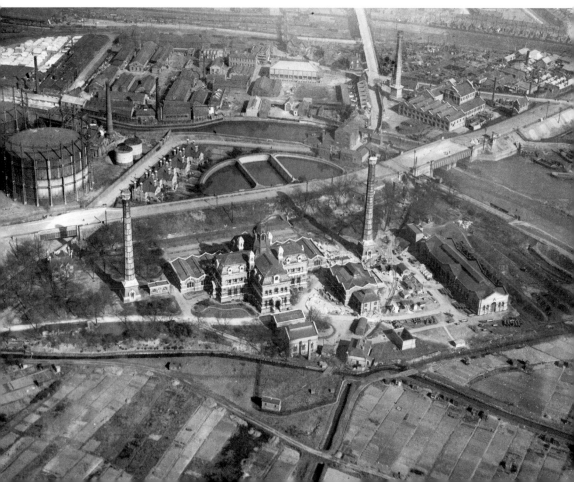

Waltham Forest

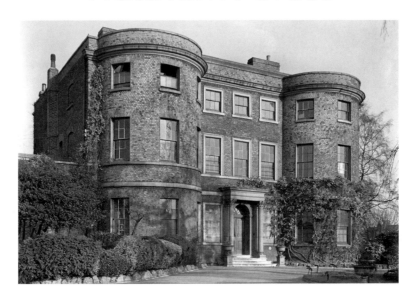

Water House
No. 99 Water House in Walthamstow was once the home of William Morris, the famous Arts and Craft designer. The house is now a museum dedicated to Morris. It stands in what were once the grounds of the house and is now Lloyd Park.

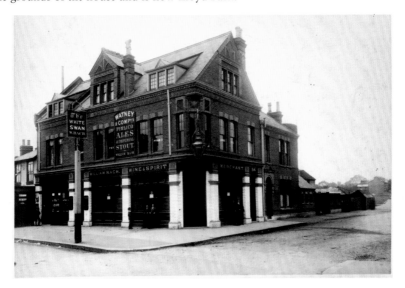

White Swan Public House
The image of the White Swan in Wood Street, Walthamstow, is shown in the 1880s. It looks a typical large Victorian public house with a group of men and boys standing outside. The White Swan closed in 2004 and became a betting shop.

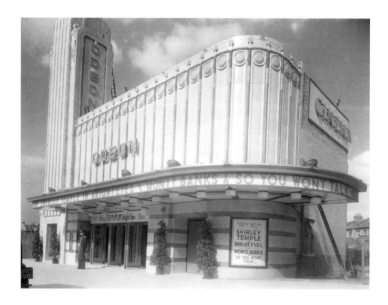

Chingford Odeon

The Odeon Cinema in Chingford was one of the original Oscar Deutsch Odeons, which often had huge towers and curves. The building fitted well into the art deco buildings in Chingford Mount when it opened in 1935. The building closed in 1977 and has been demolished and replaced with a plain shop building.

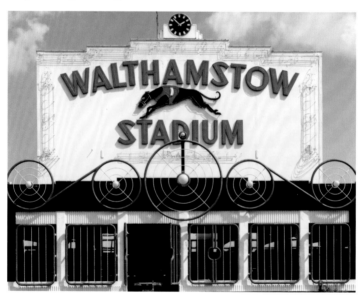

Walthamstow Stadium

Walthamstow's dog track began life in the 1920s on the old Walthamstow Grange Football Ground. In the 1930s it was redeveloped into a dedicated dog racing track and at the opening Amy Johnson was part of the attraction. It was updated on a number of occasions and was one of a number of dog racing tracks in London in the post-war period. Most have now gone, as has Walthamstow, which closed in 2005.

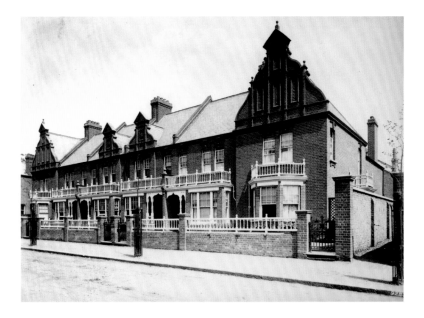

Warner Estate

In 1875 Thomas Courtney Warner inherited his father's estate in Walthamstow. Instead of selling the estate he began to build houses on the land. Many had fancy ornamentation such as those shown in the photograph taken in 1889. Warner also built shops on Walthamstow High Street.

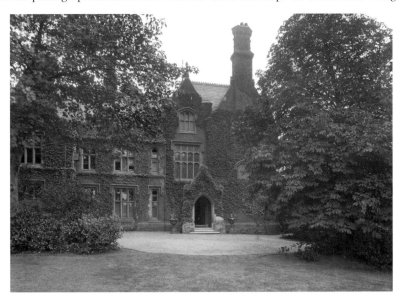

Hawkwood House

Hawkwood House was built on an estate owned by Richard Hodgson, the Lord of Chingford in 1840; it was in Yardley Lane. The house, shown in 1921, was badly damaged by enemy bombing in 1944 and was later demolished. The only part of the estate remaining is Hawkwood Lodge, which is now a children's nursery.

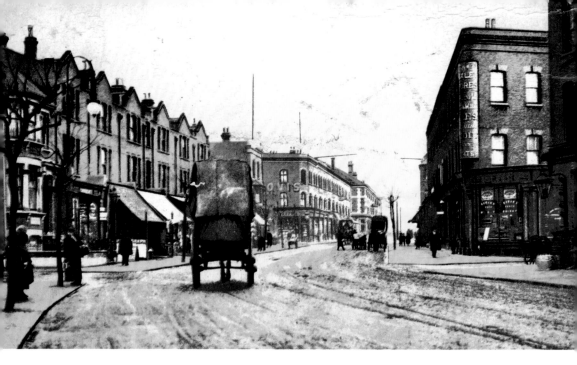

The High Road, Leyton
The High Road, Leyton, runs from Walthamstow in the north to Stratford in the south. There are two railway stations in the road: Leyton Midland Road on the Barking to Gospel Oak Line and Leyton on the Central Line.

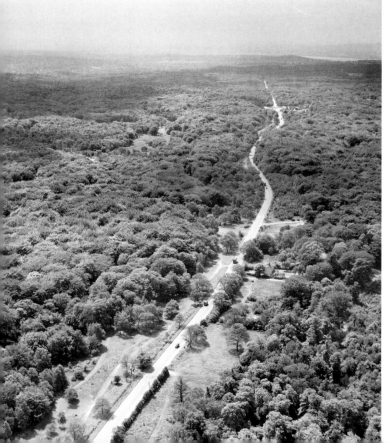

Epping Forest from Above
The aerial photograph is of Epping Forest. Much of the Borough of Waltham Forest was once or still is in the forest. In the past the forest reached as far as Romford Road, which runs from Stratford to Romford. It is no surprise then how places such as Forest Gate got their name.

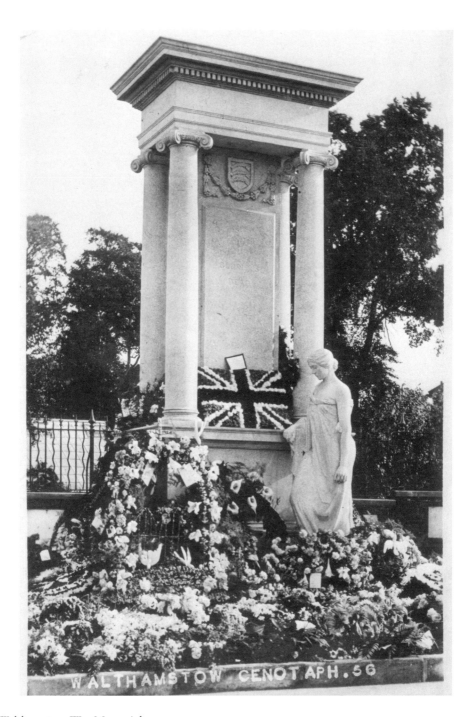

WALTHAMSTOW CENOTAPH. 56

Walthamstow War Memorial
War memorials began to appear in large numbers after the First World War. Before this they had been quite rare. The Walthamstow memorial shown in the image is of quite an unusual design with a Roman lady grieving for the loss of a loved one. The image is from the 1920s. Since then Walthamstow Town Hall has been built behind the monument.

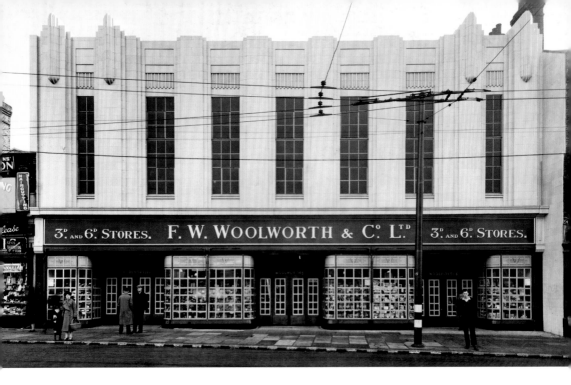

Above: Woolworths, Leyton
The photograph shows an image of Woolworths at Nos 612–614 Lea Bridge Road, Leyton, just before the Second World War. There were few high roads in East London that did not include a Woolworths shop among their retailers. The company was part of British life for many decades until it disappeared from our streets when more than 800 shops closed in 2008–09.

Below: Ferry Boat Inn
The Ferry Boat Inn dates back to the early eighteenth century. The image shown is from the late nineteenth century. There is a painting of the inn by John Bonny in the Bruce Castle Museum in Tottenham. There is some dispute over the borders where the inn stands and many claim it is in Tottenham rather than Walthamstow.

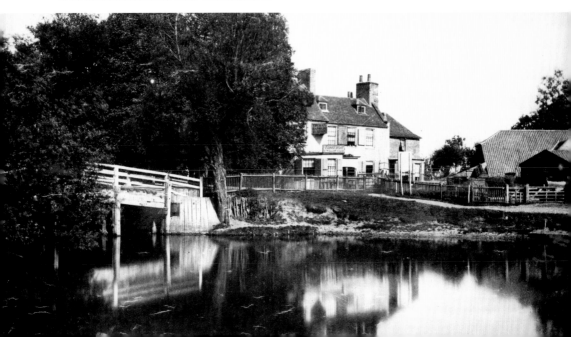

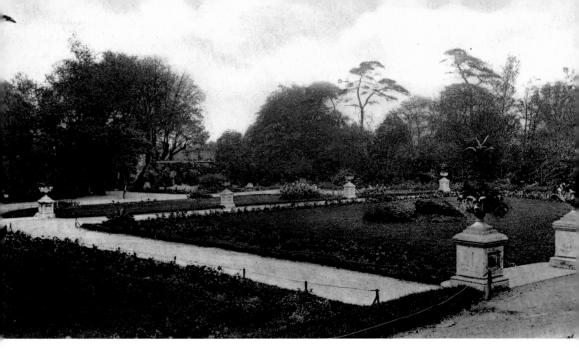

Above: Lloyds Park
The land on which Lloyd Park Walthamstow stands was once part of a large estate that was owned by the Lloyd family from 1857. After standing empty for some time the estate was presented to the local council by Frank Lloyd in 1898. It was originally planned that the park should be called William Morris Park due to his home being nearby, but it was then named after the benefactor. The image shows the park just after it opened in 1900.

Below: Springfield Park House
Springfield Park House, also known as the White House, was one of three houses whose grounds make up Springfield Park. It is the only surviving house of the three. The park opened in 1905 and has extensive views across Walthamstow Marshes.

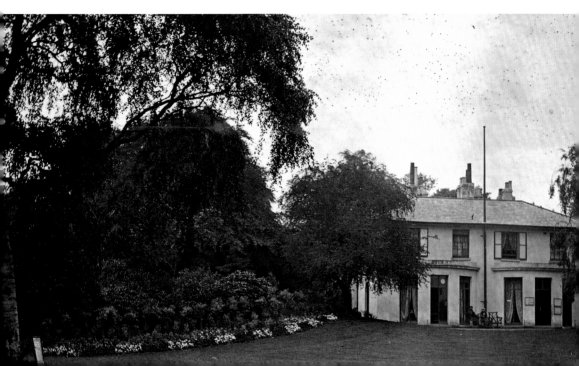

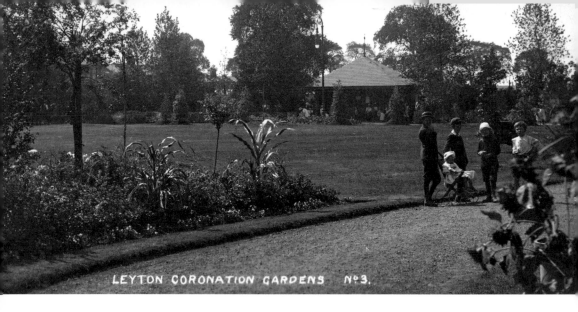

LEYTON CORONATION GARDENS NO 3.

Coronation Gardens

The image of Coronation Gardens in Leyton High Road was taken just after the land for the small park was purchased in 1902 and opened in 1903. It was named after the Coronation of Edward Vll. There was a fountain that dated from the 1920s but it was replaced in 2000.

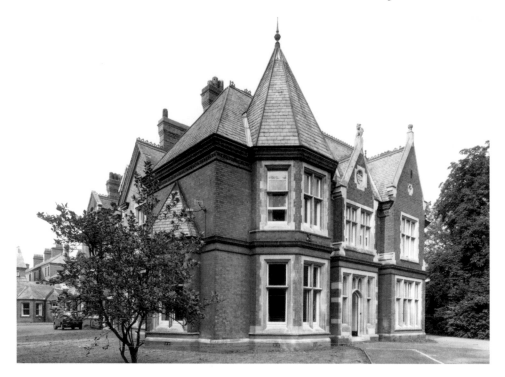

Claybury Asylum

Claybury Asylum opened in 1893 and was designed by George Hines, an expert in designing asylums. It was built on land once landscaped by Humphrey Repton. The name Claybury was taken from a fictitious village in the stories of W. W. Jacobs. It is thought that Claybury was actually Loughton where Jacobs lived. Claybury closed in 1995.

Right: Grand Bank
The photograph is of the London and South Western Bank, which began life in the mid nineteenth century, and despite amalgamating with other banks it was eventually taken over by Barclays Bank in 1918. This rather grand branch stood at No. 55 Wanstead High Street.

Below: Weaver's Almshouse
The Weaver's Almshouses in Wanstead were provided by the Weaver's Co. for retired weavers or their widows. The Wanstead houses were opened in 1859 to replace almshouses in other areas that had declined. By the 1960s non-weavers were allowed in and after extending the buildings in 1988 they became sheltered accommodation for the elderly.

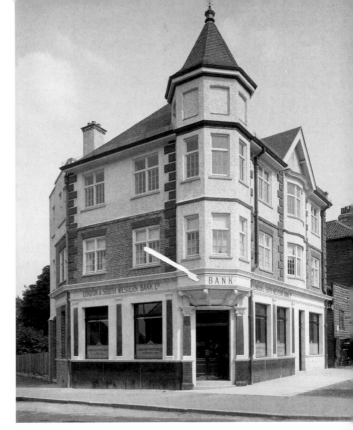

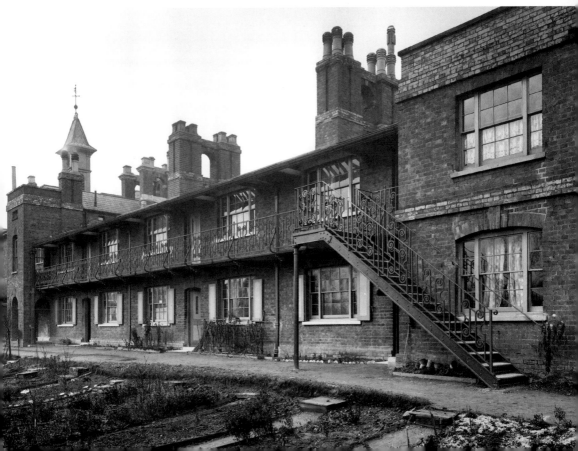

Redbridge

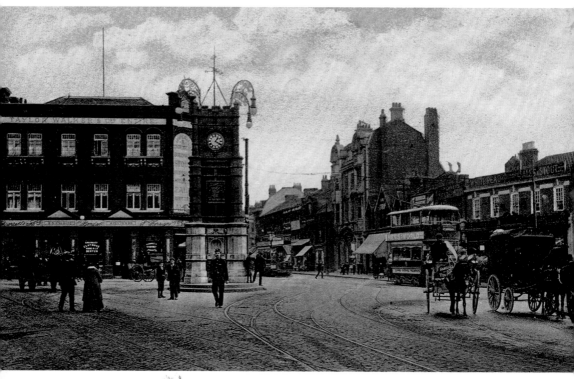

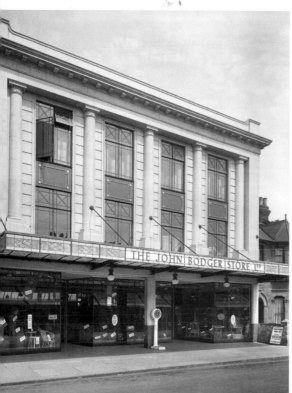

Above: The Broadway
This old card was published by Boots the Chemist. The company began in Nottingham in 1849 and by 1896 had sixty shops. The clock tower in the image was later moved to a local park when traffic increased. It was destroyed by a bomb in the Second World War.

Left: Bodgers Department Store
The existence of a department store such as Bodgers in Barkingside High Street in 1928 shows that the area was of a higher social standing than many other areas in East London. A much cheaper type of store was Woolworths, which was found in many other high streets in less affluent areas.

Gaysham Hall
It is difficult to find any details of Gaysham Hall except that it was close to Hainault Forest and dated back to at least the eighteenth century. Longwood Gardens in Barkingside, where the hall stood, now has nearly 300 homes built on it, but it is uncertain when the hall was demolished.

Ilford from Above
The aerial view is of Ilford around Valentines Park. It shows not only the open spaces but the fine houses built in the area. One area bordering the park was a Garden City. Begun by Ebenezer Howard in the nineteenth century, the idea was to combine city and countryside: not the norm for the East End, and due to expense they became Garden Suburbs instead.

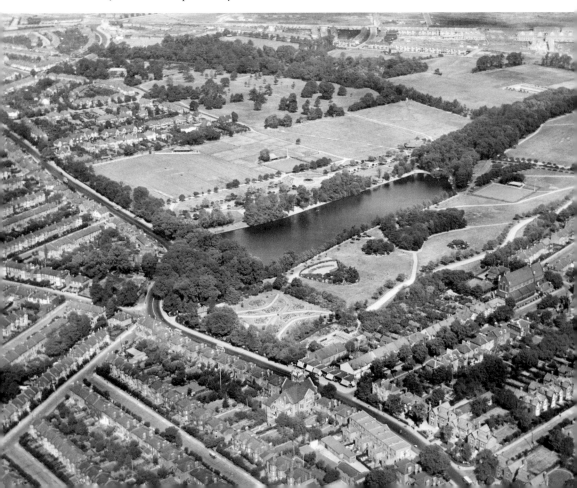

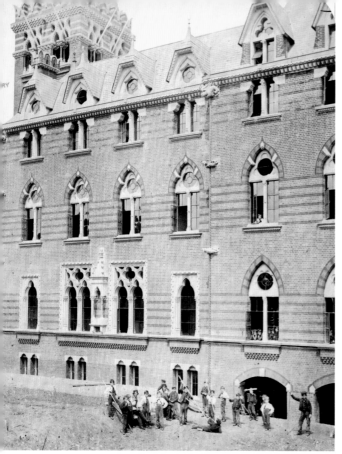

Left: Merchant Seaman Orphans' Asylum

The Merchant Seaman Orphans' Asylum opened in 1827 to provide for the orphans of merchant seamen and find them employment when they left. The orphanage moved from Bow to Hermon Hill in 1862. It later fell into financial difficulties and became a fee-paying school and then a college. The building shown was taken over by the council before the Second World War. Part of it is now flats.

Below: Ilford Prefabs

The image shows an estate of prefab houses in Theydon Road, Ilford, in 1947. A large number of these houses were built all over the East End after the war to solve the housing shortage. Many were built by German prisoners of war. There was a number of different designs for the prefabs: these are of the Seco type.

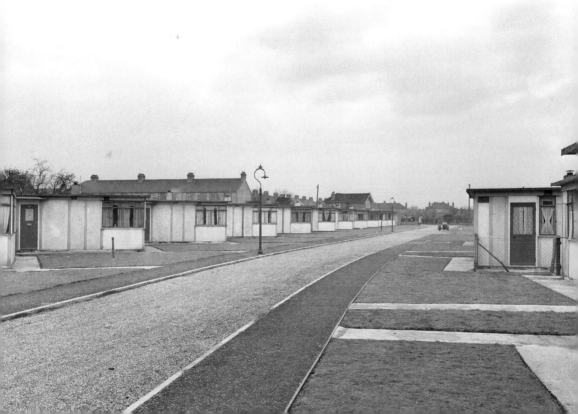

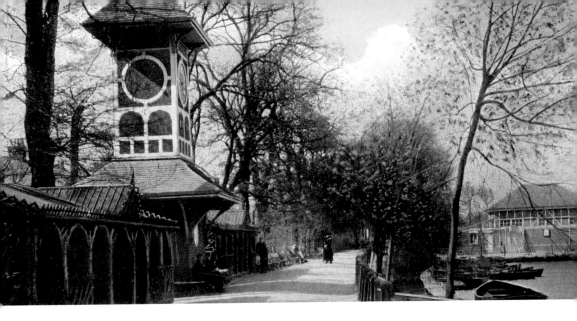

Above: Valentines Park

The image is of Valentines Park in Ilford. It was once known as Central Park and is seen as one of the best parks in the area. It has a boating lake, swimming pool and an open-air theatre. The cricket ground at the park is used by the Essex County team. The clock tower by the lake supposedly came from the stables of Cranbrook House. The park is one of the finest open spaces found in the East End.

Below: Doctor Barnardo

Doctor Barnardo opened homes for destitute children in London in the nineteenth century. He opened a home in Barkingside in 1876 after being given the land there rent-free. The image shows the Girls' Village in Queen Victoria House. The house survives and is now the registrar's office for Redbridge.

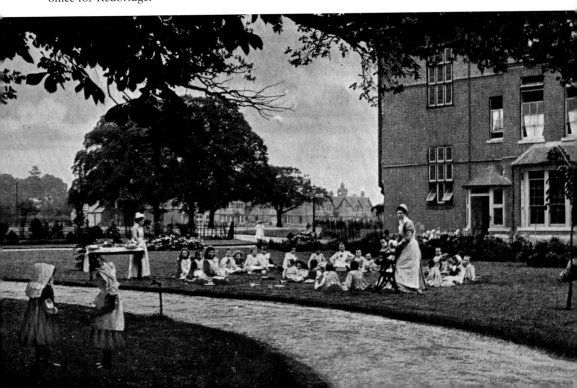

Barking and Dagenham

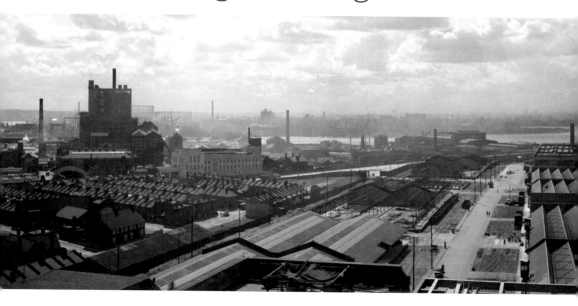

Above: Dagenham Dock
The photograph shows one of the most industrialised areas of Dagenham just after the Second World War. The area around Dagenham Dock on the Thames was acquired by Samuel Williams in 1887. He built the dock and a rail line. He then went on to build an industrial estate around it. Much of the area was later taken over by Ford.

Below: Ford Motor Co.
The Ford Motor Co. began to build its Dagenham factory on the Thames after buying 244 acres of land from Samuel Williams in 1924. The building began in 1929 and covered much of the riverfront in Dagenham. The site of the factory was later divided by the Channel Tunnel Rail Link and the new A13 road. Much of the factory has now been demolished.

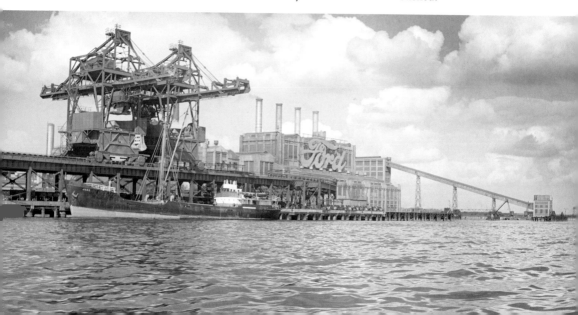

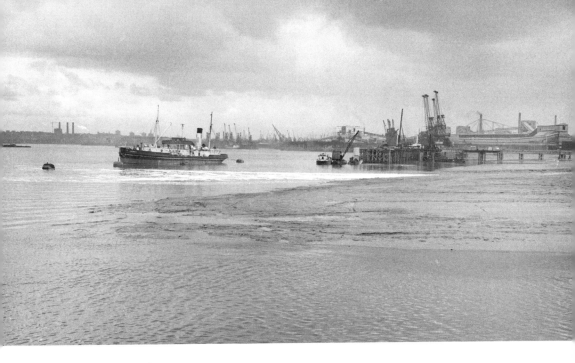

Above: Barking Creek

Barking Creek leads from the Thames along to the Town Quay in Barking. It was once the base of a large fishing fleet, which sailed out to sea from there. The Creek, which is part of the River Roding, was navigable by barge up to Ilford. After the fishing industry moved away a large number of factories were built along the banks of the river and were often supplied by ship from the Thames.

Below: East London Waterworks

The image shows the East London Waterworks Co. at Barking in 1896. The company had the rights to supply water to Barking from 1853 but had done little to do so and the town had instead been supplied by the South Essex Waterworks Co. This was described as expensive and inefficient. The East London Waterworks Co. did then dig some wells.

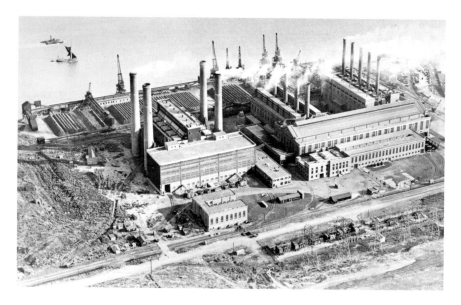

Barking Power Station

Barking Power Station was situated on the bank of the Thames at River Road. The first station was built in the late nineteenth century. In 1925 it was replaced by what was to be the largest power station in Britain constructed as a single facility. It was closed and demolished by the 1980s, but more modern stations have been built in Dagenham close to the old Ford works.

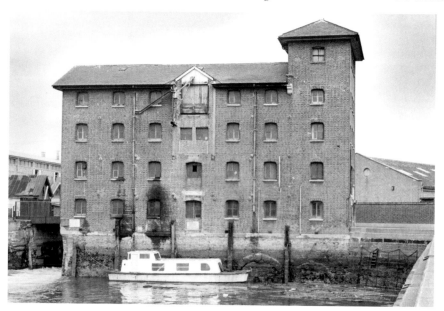

Old Granary

The Old Granary at Barking Town Quay is one of the very few old buildings to survive from its glory days as a major fishing base. The other warehouses and buildings that once lined the banks have been demolished and replaced by modern homes and a large open space facing the ruins of Barking Abbey and the town centre.

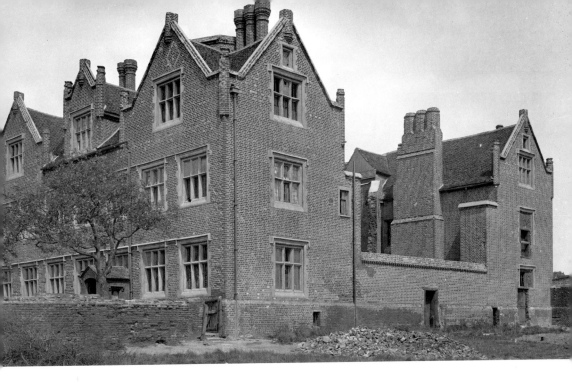

Above: Eastbury House

Eastbury House dates back to the sixteenth century and is often wrongly attributed to playing a part in the gunpowder plot of Guy Fawkes. The building was left to fall into disrepair in the early twentieth century but has since been restored and is now open to the public.

Below: Dagenham Prefabs

The image shows a prefab house in 1946 built by Briggs of Dagenham. Briggs later built car bodies for Ford. The house was unusual in that it was two stories – most prefabs were single storey. It was also built of metal. There is an old saying that Dagenham was once known as 'corned beef city'. This was because a number of metal houses in the town were said to have been built from old corned beef cans.

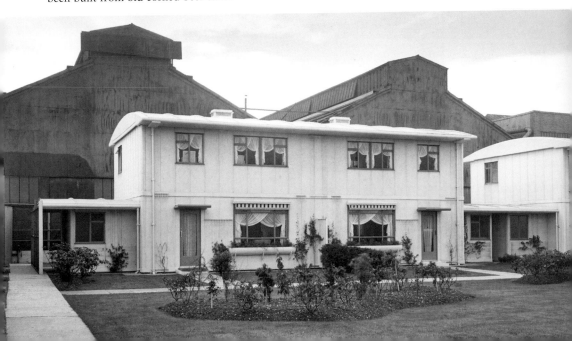

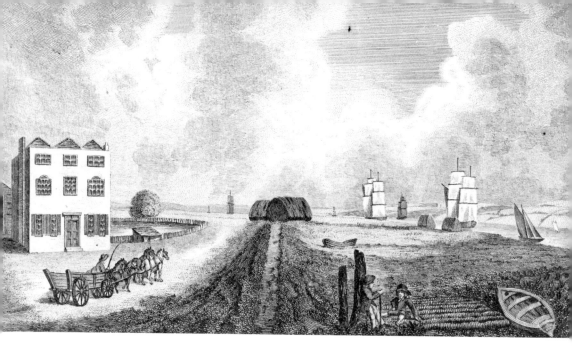

Above: Breach House

The old print dates from the late nineteenth century and shows Breach House, which stood on the Thames where Ford was later built. The area was reached by Chequer's Lane and the Chequer's pub, which stood at the top of the lane, was a well-known landmark for trippers from London coming down to Dagenham for a day out. Breach House was used as a holiday home by prison reformer Elizabeth Fry.

Below: Sterling Works from Above

The aerial view shows the Sterling Works in Dagenham in 1921. Sterling was one of the largest workplaces in the area at the time, although most of their workers came from the towns around Dagenham. As can be seen, Dagenham at this time was mainly rural, although soon after this photograph was taken building began on what was to become the largest council estate in the world.

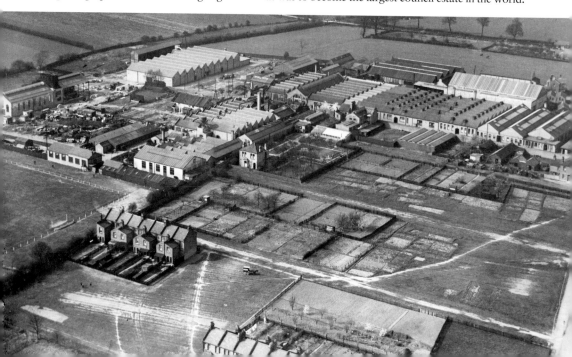

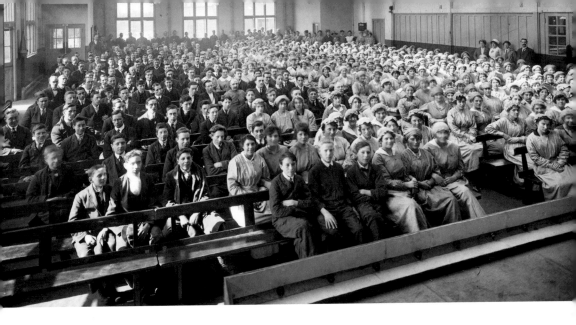

Above: Sterling Works

The interior of the Sterling Works in 1917 was dominated by women. This was because so many men were away fighting in the First World War. The war gave women a rare opportunity to experience life outside the home. Sterling had a thriving social club that included a woman's football team, who played against other factory teams in Essex. The Sterling sports ground where the women played is now the home of Dagenham & Redbridge FC and the Sterling industrial estate borders the ground, although Sterling itself has long gone.

Below: Woolworths Dagenham Heathway

The image shows Woolworths in Dagenham Heathway just before the Second World War. Dagenham had a number of small shopping centres, which were built along with the Becontree Estate. Heathway, despite having an underground station, could not compare with Romford or Barking as a shopping centre but was perhaps the largest in Dagenham.

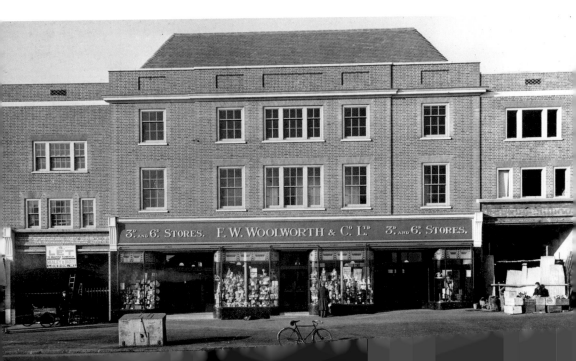

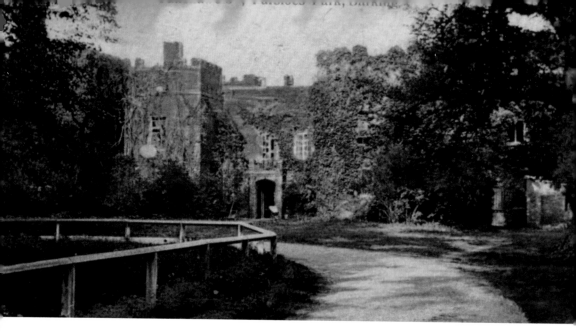

Above: Parsloes House

The image shows Parsloes House at the end of the nineteenth century. It was one of the large houses that stood in Dagenham before the Becontree estate was built. It had become derelict and was demolished in 1925. The name is remembered in what were the grounds of the house, which is now Parsloe Park. The parks in Dagenham may be as large as other East End parks but tend to have much less in the way of facilities.

Below: Ashbrook Dairy

Ashbrook Dairy is another of the large houses that existed in Dagenham – not as grand as some but much bigger than the average house in the town. It survived until the 1960s when it was demolished and a row of houses was built on the site. A shop called Ashbrook Dairy survived much longer next to the houses but was eventually also demolished and had flats built there. The dairy stood almost opposite what is now the Barking Registrar's Office.

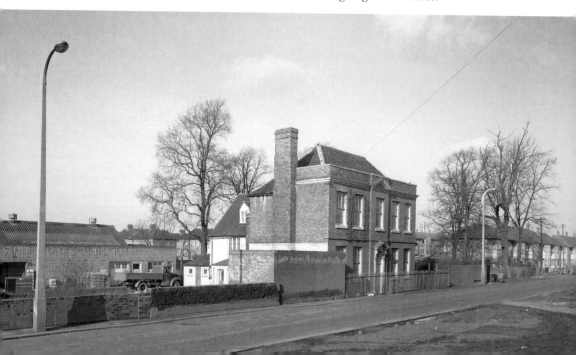

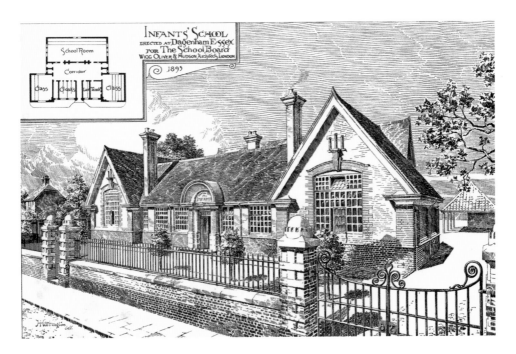

Ford School

The school in Church Elm Lane shown in 1895 was called William Ford. It was one of the first schools in Dagenham and opened in 1826 due to a legacy left by William Ford, a Dagenham farmer – not to be confused with Ford Motor Co. In 1841 a new building was completed with a teacher's house. The school was later demolished but a new school was built – also called William Ford – and by coincidence is in nearby Ford Road.

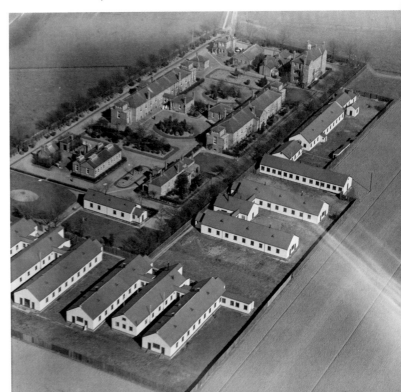

Dagenham Hospital from Above

The aerial view is of Dagenham Hospital. It began life in 1899 as a smallpox hospital built by West Ham Council in what was a very rural site at Rookery Farm near the River Rom. It became a TB sanatorium in 1912. After the Second World War it became Dagenham Hospital and was closed in 1986. It has since been demolished and the land has become a country park.

Havering

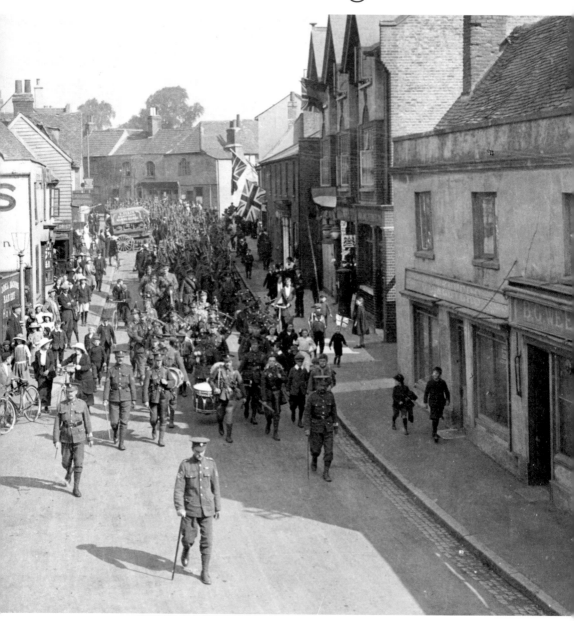

Sportsman's Battalion
The soldiers marching along Hornchurch High Street in 1915 were the Sportsman's Battalion, a special unit made up of sportsmen and men from the world of entertainment. They were based at Grey Towers House in Hornchurch for training until they left thinking they were on their way to France but instead went to another camp in England.

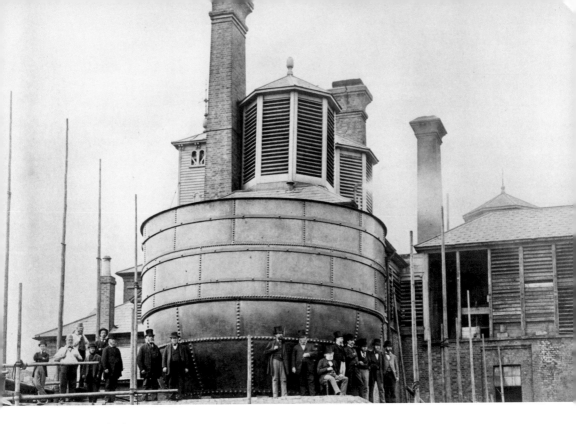

Above: Romford Brewery
Romford Brewery had a long history, opening in 1708 and connecting with the Star Inn, High Street. It became Ind Coope in 1845. The image shows a 1,000-barrel copper being installed in 1873. The brewery closed in 1993 and is now a shopping centre and a museum. There is a large copper still standing by the entrance to the shopping centre car park.

Below: Rose Court
Rose Court, Havering Road, was previously called Cromwell House when built in 1858. It was later changed to Havering Court and one of its tenants was Herbert Raphael, a well-known name in Romford. The court was damaged by fire in the 1930s and was mostly demolished in the 1970s.

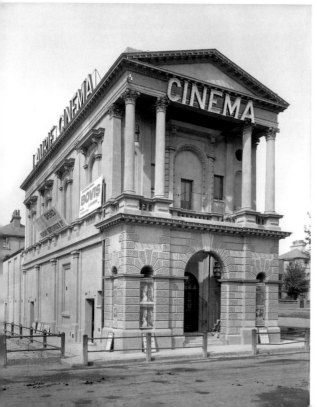

Above: Gidea Park
Gidea Park, Romford, is the area mainly surrounding Raphael's Park. It was built as Romford Garden Suburb just before the First World War. Much of the area was once the grounds of Gidea Hall, once owned by Sir Herbert Raphael and Hare Hall, which became an army camp for the Artist Rifles during the war and was once the home of a number of the well-known war poets of the period.

Left: Laurie Hall
The Laurie Hall stood at the East End of Romford Market Place. It was once the Town Hall in the nineteenth century but in 1913 it became a cinema. It dominated the Market Place for many years until during the 1970s it was demolished along with nearby Laurie Square as the market became pedestrianised and a ring road was built around the town centre.

Right: Rainham Hall
Rainham Hall was built in 1729 for Captain John Harle, who owned Rainham Wharf. His wife and his initials are still present in the railings surrounding the house. Harle was strongly responsible for the growth of Rainham in the eighteenth century, dredging the River Ingrebourne so that boats could reach Rainham from the Thames. The house was given to the National Trust in 1949 but only opened to the public in 2015.

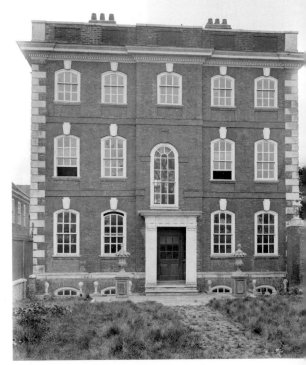

Below: Romford Market from Above
The aerial image shows Romford Market Place and St Edwards Church looking eastwards in 1921. The Laurie Hall is visible at the far end and there was still a road running through the marketplace then; even buses travelled through the market and on to Main Road. There is now a subway close to where Laurie Hall stood under the ring road leading to the Town Hall and library.

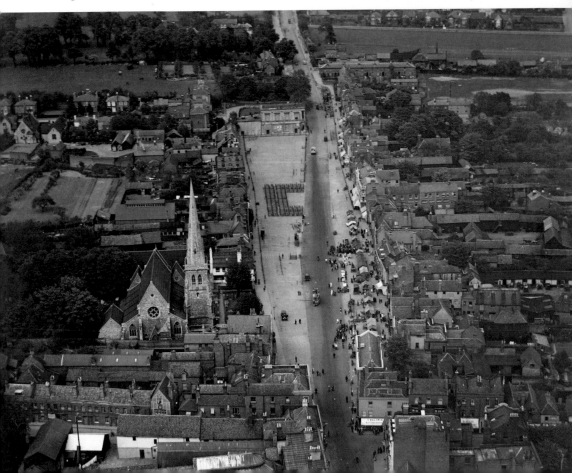

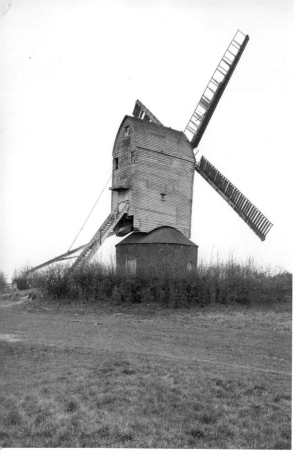

Left: Hornchurch Mill

The windmill at Upminster is better known than Hornchurch Mill, mainly as it still survives. The mill in Hornchurch dates back hundreds of years and is shown in 1918. The mill and mill house stood near St Andrews Church in the Mill Field. The field was used for sporting events that once included prizefighting and cockfighting. The mill closed just before the First World War and burned down just after it, but the house has survived.

Below: St Andrew's Church

St Andrew's Church, Hornchurch, dates back to the eleventh century and was once the only church in Havering. The present building is not that old, although part of it does date from a few centuries after the original was built. The churchyard contains the graves of many local dignitaries as well as a number of war graves from both wars, mainly connected to the airfield that stood in Hornchurch. It also contains the graves of some Maori soldiers who were based at the New Zealand Military Hospital in the town during the First World War.

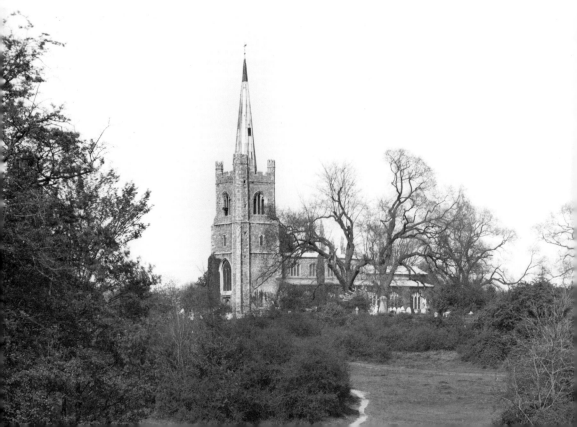

Right: Hornchurch Village
The photograph taken in 1918 shows part of what was then Hornchurch village. The High Street was very narrow with a number of old houses and some shops. It was also full of military personnel from both a large camp at Grey Towers House and from the nearby airfield where three of the pilots were responsible for shooting down the first German airships to fall to British pilots.

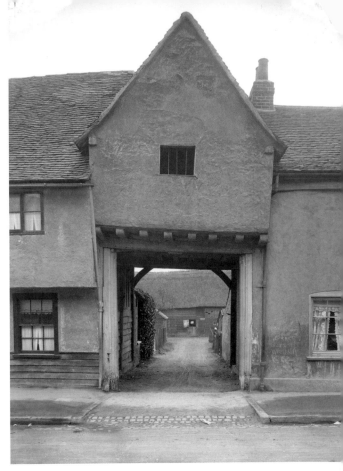

Below: Raphael's Park
Raphael's Park was presented to the town by the Raphael family, who lived at Gidea Hall before the First World War. It is thought to have been a concession to the town to allow a housing estate that covers the rest of the Gidea Hall grounds to be built. The lake in the park was once known as Black's Canal after a previous owner of Gidea Hall who was not popular with locals. The bridge over the river that is part of main road was known as Black's Bridge.

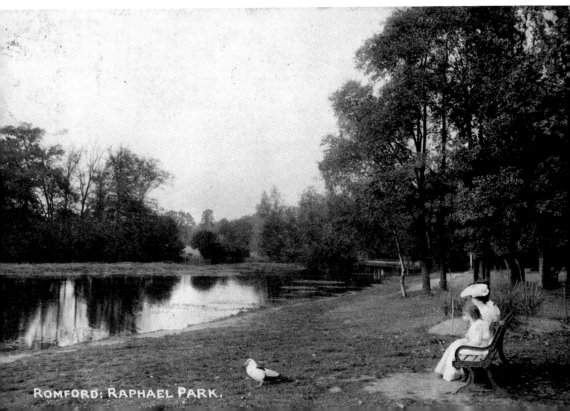

ROMFORD: RAPHAEL PARK.

About the Archive

Many of the images in this volume come from the Historic England Archive, which holds over 12 million photographs, drawings, plans and documents covering England's archaeology, architecture, social and local history.

The photographic collections include prints from the earliest days of photography to today's high-resolution digital images. Subjects range from Neolithic flint mines and medieval churches to art deco cinemas and 1980s shopping centres. The collection is a vivid record both of buildings that are still part of everyday life – places of work, leisure and worship – and those lost long ago, surviving only in fragile prints or glass-plate negatives.

Six million aerial photographs offer a unique and fascinating view of the transformation of England's towns, cities, coast and countryside from 1919 onwards. Highlights include the pioneering photography of Aerofilms, and the comprehensive survey of England captured by the RAF after the Second World War.

Plans, drawings and reports provide further context and reconstruction artworks bring archaeological sites and historic buildings to life.

The collections are housed in a purpose-built environmentally controlled store in Swindon, which provides the best conditions to preserve archive items for future generations to enjoy. You can search our catalogue online, see and buy copies of our images, as well as visiting our public search room by appointment.

Find out more about us at HistoricEngland.org.uk/Photos
email: archive@historicengland.org.uk
tel.: 01793 414600

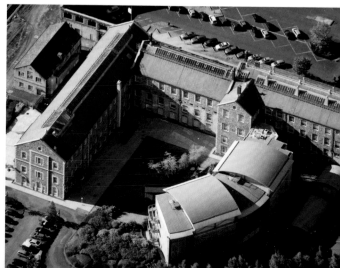

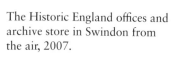

The Historic England offices and archive store in Swindon from the air, 2007.